HAMPSHIRE AT WAR
THROUGH TIME
Henry Buckton

AMBERLEY PUBLISHING

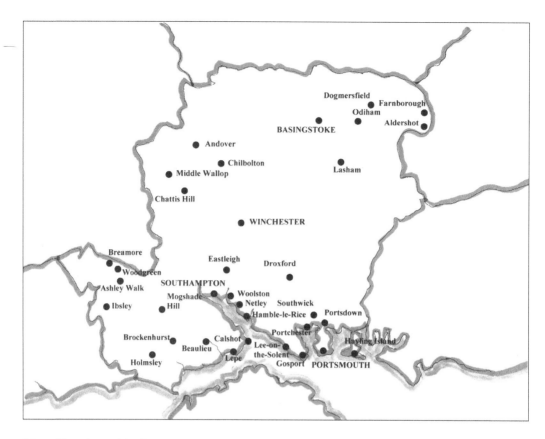

Map of locations visited.

First published 2013

Amberley Publishing
The Hill, Stroud
Gloucestershire, GL5 4EP

www.amberley-books.com

Copyright © Henry Buckton, 2013

The right of Henry Buckton to be identified as the
Author of this work has been asserted in accordance
with the Copyrights, Designs and Patents Act 1988.

ISBN 978 1 4456 1404 5

British Library Cataloguing in Publication Data.
A catalogue record for this book is available from
the British Library.

Typeset in 9.5pt on 12pt Celeste.
Typesetting by Amberley Publishing.
Printed in the UK.

Introduction

In the early hours of 6 June 1944 Allied troops landed on the coast of northern France. Located directly opposite the Normandy beaches, the county of Hampshire would become the main springboard for Operation *Overlord*, the codename for the invasion of Europe. But in telling the story of Hampshire at War we go right back to the start of hostilities, on a geographical journey around many locations in the county that were somehow involved.

We see how Portsmouth and Southampton were both heavily bombed during the Blitz but later became important embarkation areas during D-Day. We note the crucial industries of the area, particularly shipbuilding and aircraft manufacturing – Hampshire was very much the home of the Supermarine Spitfire. We see how Gosport provided the Royal Navy with everything it needed from food to ammunition; study some of the defences that were built in 1940 to protect the country from invasion, particularly the Basingstoke and Ringwood Stop Lines; the part played by numerous airfields in the New Forest, at first helping to protect southern England and then taking the fight back across the Channel; examine the important part played by Middle Wallop during the Battle of Britain and by Farnborough in keeping Britain's aircraft technology ahead of the game.

Because of its location directly opposite the German front line, Hampshire was one of our most active counties during the Second World War and hopefully this book will go a little way to describe its varied and strategic roles.

Henry Buckton

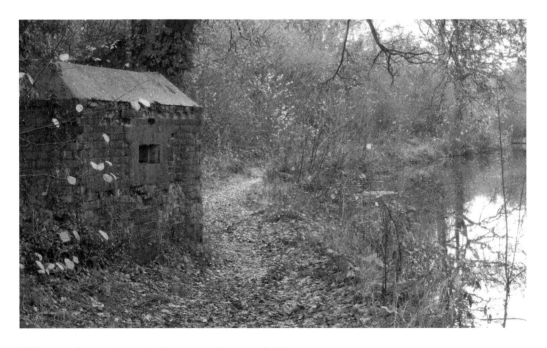

Pillbox on the Basingstoke Canal near Dogmersfield.

Acknowledgements

Photo credits:
Author: top 12, 13, 24, 29, 31, 36, 38, 74, 75, 76, 92, 93; bottom 3, 7, 8, 10, 11, 12, 13, 15, 16, 17, 18, 19, 20, 21, 23, 24, 25, 26, 29, 30, 31, 32, 33, 34, 36, 37, 38, 39, 40, 52, 54, 55, 58, 66, 67, 71, 72, 73, 75, 76, 77, 79, 82, 84, 85, 86, 87, 91, 92, 94, 95, 96. Author's collection: top 8, 17, 21, 43, 44, 45, 46, 47, 49, 56, 60, 61, 62, 73, 78, 79, 86, 95; bottom 43. Sylvia Atkinson: top 96. Paul Chryst: top 69. Peter Garwood, Balloon Barrage Reunion Club: top 37. Trevor Gray: top 52. Win Harfield: top 85. Severnside Aviation Society: top 80, 81, 82. Don Smith: top 51, 94. Michael Virtue, Virtue Books: top 5, 6, 7, 9, 11, 19, 22, 23, 25, 26, 32, 33, 34, 41, 42, 48, 53, 55, 57, 58, 77, 90; bottom 42, 89. The 225th Anti-Aircraft Artillery Searchlight Battalion (US Army): top 59. I would like to thank the following contributors to the Hampshire Airfields website for the use of their photographs by permission of Dave Fagan: J. Booth: top 54. Mike Burnett: top 63. Tony Dewey: top 83. Dave Fagan: top 10, 39, 40, 64, 65, 66, 67, 68, 70, 71, 87, 89; bottom 63, 65, 68. Trevor Jago: top 50. I would also like to thank the following members of the Geograph website for the use of their photographs, licensed for reuse under the Creative Commons License. Colin Babb: bottom 60. Sebastian Ballard: bottom 93. Gordon James Brown: top 35; bottom 35. Stuart Buchan: top 72. Anne Burgess: bottom 47. Jim Champion: bottom 69, 70. Lewis Clarke: bottom 50. Don Cload: bottom 74. Steve Daniels: bottom 44. Richard Dorrell: bottom 64. Matt Eyre: bottom 14. Peter Facey: bottom 53. Mike Faherty: bottom 57. Dave Jacobs: bottom 61. Kevin Legg: bottom 41. David Mainwood: bottom 48. Terry Robinson: bottom 45, 59. Richard Rogerson: bottom 88. Mike Serle: bottom 78. Colin Smith: top 88; bottom 5, 6, 22, 90. Chris Talbot: top 91; bottom 80, 81, 83. Peter Trimming: bottom 46, 51, 56, 62. Alan Walker: bottom 49. Stephen Williams: bottom 9. Thanks also to RuthAS for photograph licensed for reuse under the Creative Commons License: top 84. The following pictures are reproduced from *Smitten City: The Story of Portsmouth under Blitz* published by *The Evening News*, Portsmouth (1946): top 14, 15, 16, 18, 20, 27, 28, 30; bottom 27, 28.

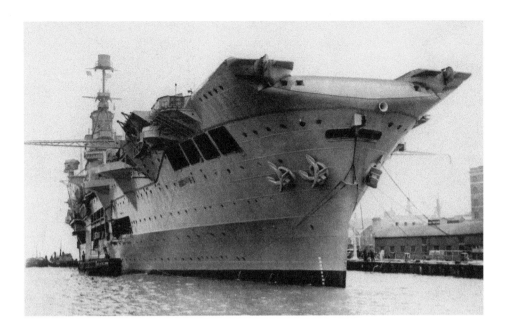

Evacuating the Fleet

Because of its importance as the home of one of Britain's major pre-war naval bases, Portsmouth was bombed by the Germans almost continually throughout the war. However the Royal Navy kept very few vessels here during hostilities. Their capital ships, such as aircraft carriers and battle cruisers, were evacuated to bases in Scotland and the North of England. Above we see the floating aerodrome HMS *Ark Royal* at Portsmouth, her home port, in January 1940, where she was quickly refueled and cleaned before sailing out again. Below we see the historic dockyard today, photographed from the Spinnaker Tower.

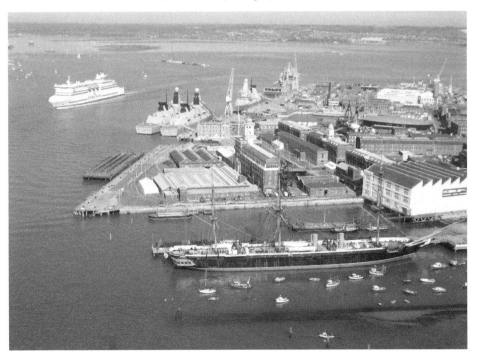

Protecting the English Channel

After the fleet was evacuated little more than a flotilla of destroyers was left in Portsmouth, which were considered the essential minimum for the defence of the English Channel against any potential invasion. These were particularly active during Operation *Dynamo*, the evacuation of Dunkirk, helping to protect the armada of small ships. And of course throughout the war Portsmouth dockyard served as a major refit and repair centre. Above we see a vessel being towed into the docks for repair during the conflict while below a modern warship can be seen berthed in Portsmouth's dockyard today.

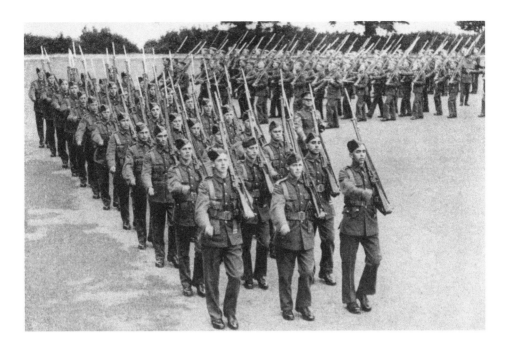

Royal Marines at Eastney

There were a number of military installations around the city, such as Eastney Barracks, home of the Royal Marines. It was here that the Cockleshell Heroes were based, using the seafront at Eastney, the Canoe Lake on Southsea Esplanade, and the sailing club at Black Point on Hayling Island to train for daring raids like Operation *Frankton*, which targeted shipping in Bordeaux Harbour in December 1942. Some of the barracks are now preserved as the Royal Marines Museum. Above, wartime Marines are seen on the parade ground and below, a statue of a Marine stands guard in front of the former barracks.

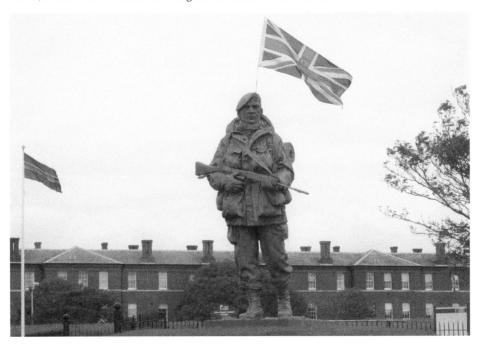

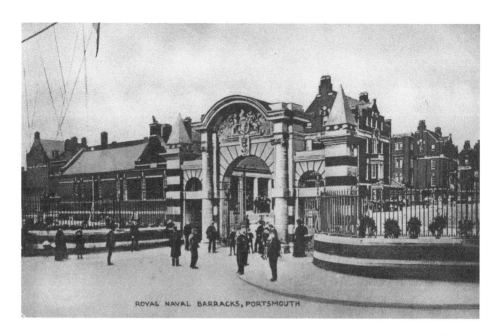

ROYAL NAVAL BARRACKS, PORTSMOUTH

Royal Naval Barracks

The Royal Naval barracks in Portsmouth were known as HMS *Victory*, not to be confused with Admiral Nelson's flagship of the same name which of course now takes pride of place in the historic dockyard. The impressive structure pictured above before the war and below today, which can be found along Queen Street, was once the main gate to the establishment. During the bombing of the city the commander-in-chief of Portsmouth, Admiral Sir William James, ordered 1,000 sailors from the barracks to help clear the streets of debris, and aid those who had been bombed out by salvaging their possessions.

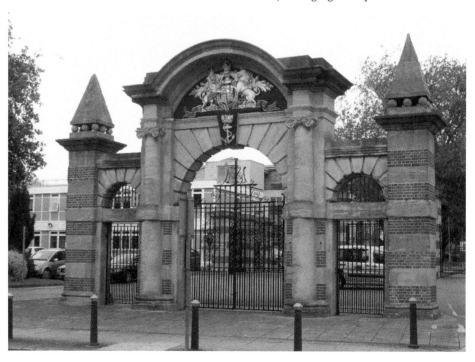

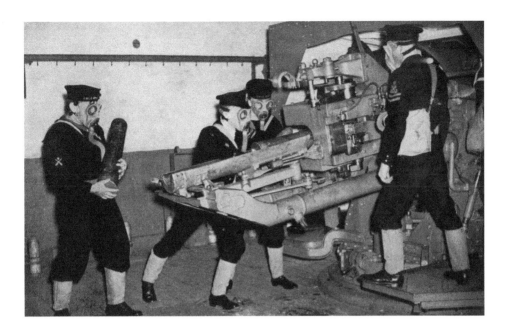

Gunnery School on Whale Island

Another naval establishment in the area was HMS *Excellent* on Whale Island in Portsmouth Harbour, which included the Royal Naval Gunnery School. Here both officers and ratings trained intensively with the various types of guns that would be found on board British warships at the time. During training the officers wore white trousers, to distinguish them from the men. The photograph above shows students at the school learning how to load and operate one of the establishment's weapons. Below is an aerial view of Whale Island taken in 1976.

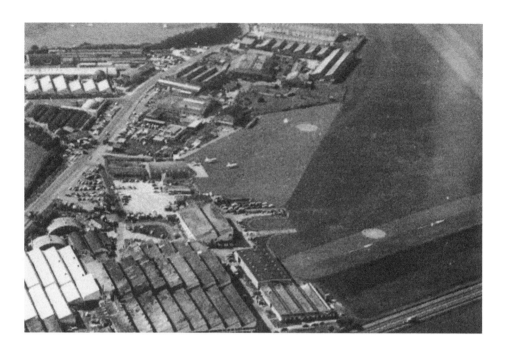

War Work

There were also a number of factories around Portsmouth heavily involved in war work, such as Vospers Shipbuilding at Portchester which was on the site of the current Drystack shipyard (*below*). They were a prolific builder of Motor Torpedo and Motor Gun Boats for the Royal Navy, as well as high-speed launches for the Royal Air Force that were used to rescue ditched aircrew. There was also the Airspeed factory (*above*) on what was later to become Portsmouth airport. This factory built Airspeed Oxford aircraft and Horsa gliders which would be used by both American and British airborne forces on D-Day.

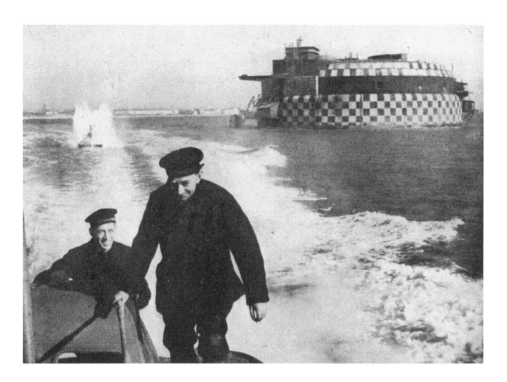

Solent Sea Forts

The fact that the Royal Navy evacuated its largest vessels from Portsmouth illustrates that the military and civil leaders of the city appreciated that it would be a relatively easy target for the Germans to find and bomb. With this in mind it was heavily protected with both anti-aircraft guns and barrage balloons. Above we see one of the unmistakable sea forts that were built in the Solent in the 1860s at the time of a feared invasion by the French. During the Second World War these would be heavily armed and garrisoned by the Royal Artillery. Below we see what remains of one of these forts today.

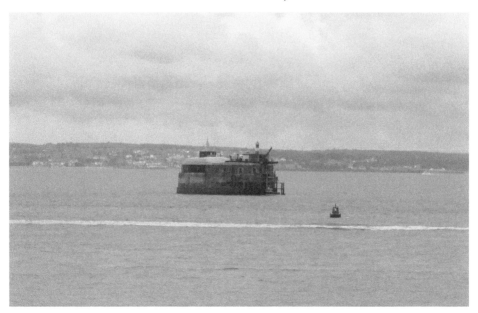

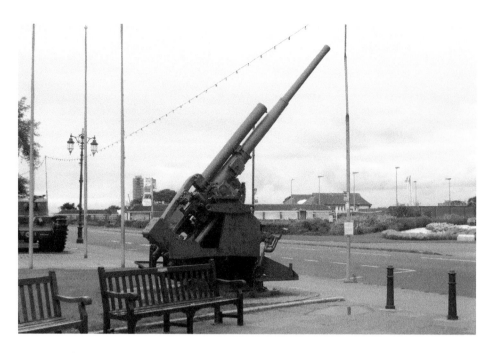

Portsmouth's Anti-Aircraft Defences

These two photographs show some of the armaments that were deployed around Portsmouth during the war that you can still find in the city today. The example above is a 3.7 inch anti-aircraft gun, which can now been seen on Clarence Esplanade near the D-Day Museum. This calibre of weapon was effective against enemy aircraft flying at anything up to 32,000 feet. There were sixteen of these batteries at different sites around the city, as well as sixteen 4.5 inch guns, and four 3 inch guns, like the one pictured below, which you will now discover along the waterfront at Gunwharf Quays.

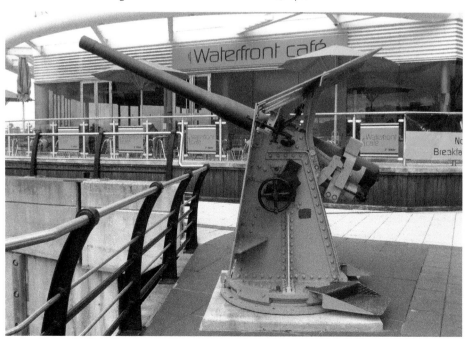

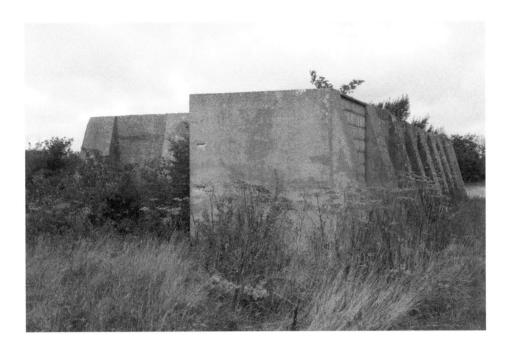

Tragedy on Sinah Common

There was a 4.5 inch anti-aircraft battery on Sinah Common on Hayling Island, where there was also a decoy made up of structures filled with oil that would be set alight to trick the bomber pilots into thinking that Langstone Harbour was the naval dockyard. During the night of 17/18 April 1941, this worked well but unfortunately the battery received a direct hit. All the buildings were destroyed or damaged and a plaque in one of the surviving gun emplacements lists the names of the six gunners who died. Above is an ammo store on the site and below, the remains of one of the gun emplacements.

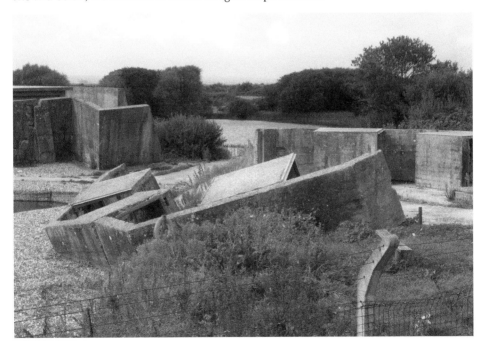

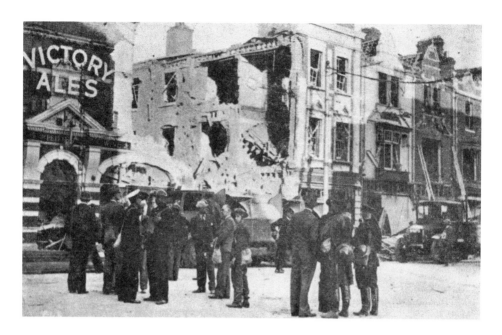

The Portsmouth Blitz

In spite of these precautions, the inevitable aerial onslaught when it came would be devastating. The bombing of Portsmouth by enemy aircraft lasted from July 1940 until May 1944, during which time there were sixty-seven recorded raids, three of which were particularly severe. These took place on 24 August 1940, 10 January 1941, and 10 March 1941. Among the first buildings to be destroyed was the Blue Anchor hotel at Kingston Cross, which was hit on the night of 11 July 1940 (*above*). The one-storey building seen below was built as a temporary replacement but still survives.

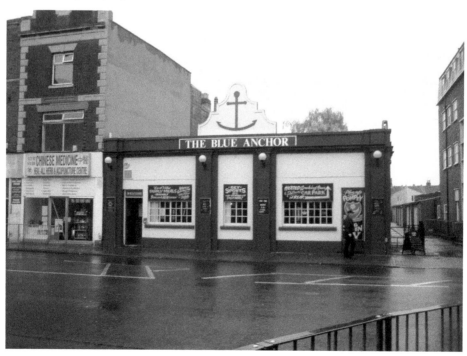

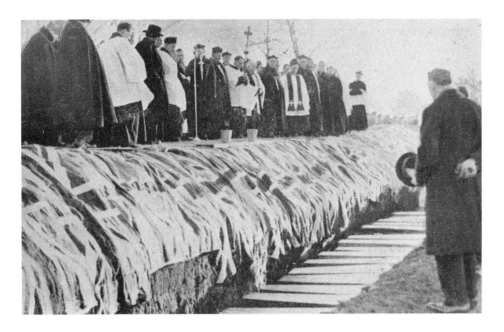

Mass Grave at Kingston Cemetery

It is estimated that in all attacks approximately 1,320 high-explosive bombs were used, along with 38,000 incendiary devices and thirty-eight land-mines, the latter being the most destructive. In total 930 civilians were killed, with another 1,216 hospitalised. Hundreds of the victims, many unidentified, were buried in a mass grave at Kingston Cemetery. The photograph above captures the sad sight of multiple graves lined up during the burial ceremony. The memorial below, listing the names of those who perished, can now be found close to the grave site.

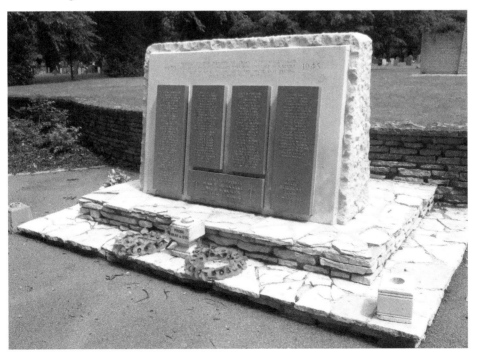

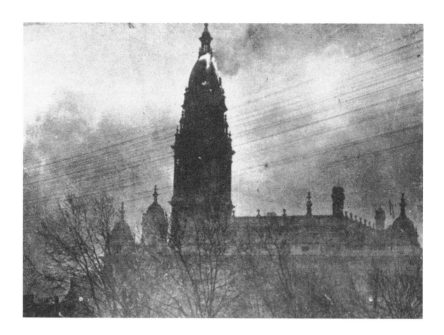

Gutted by Fire

As well as civilians, many service personnel were also killed while working in the streets, in the dockyard, or in other naval or military establishments. The Royal Naval barracks were bombed several times, the worst occasion on 17 April 1941 when thirty-three people were killed. Many of Portsmouth's most iconic buildings were also either damaged or completely destroyed. The Guildhall was gutted by fire (*above*) after it was hit by incendiary bombs, with many historic artifacts lost to the flames. Luckily the mace presented to the city in 1658 was found unscathed. Below we see the Guildhall today.

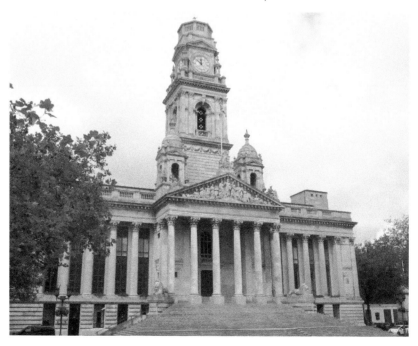

Destruction of Amenities

Other damage recorded around the city included thirty churches destroyed. The picture to the right shows the 700-year-old Royal Garrison church, the bombed-out remains of which are preserved to this day (*below*). Eight schools were also razed to the ground including Drayton Road School. Four cinemas were destroyed, such as the Prince's Theatre in Lake Road and the Hippodrome in Commercial Road, as well as around 150 pubs and other licensed premises. A number of shopping areas were also virtually obliterated including Commercial Road in Portsmouth and Palmerston Road in Southsea.

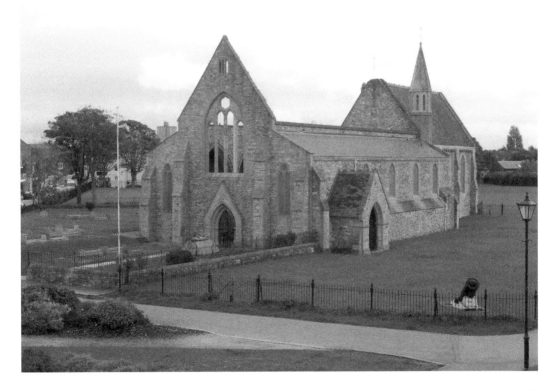

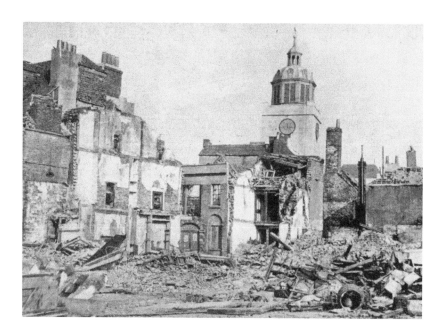

Portsmouth Cathedral Unscathed

Although the photograph above of Oyster Street in Old Portsmouth might suggest otherwise, the Anglican cathedral was itself unharmed (*below*). The damage recorded to residential properties was massive with over 80,000 dwellings sustaining some form of air-raid effect. More than 6,500 were completely destroyed. The Conway Street area of Landport was flattened by a single explosion. A land-mine is thought to have torn through the frail old cottages, doing more demolition work in seconds than the Corporation had done in years, as apparently the whole area was scheduled for rebuilding anyway.

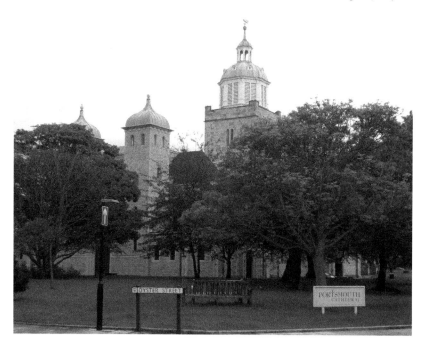

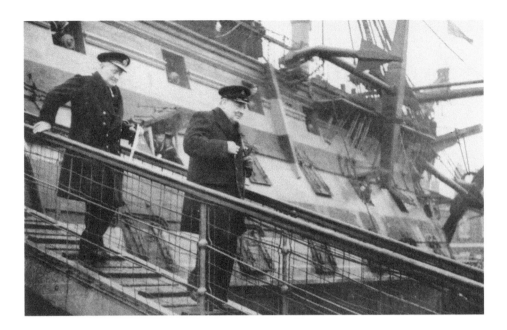

The Prime Minister Pays a Visit

During the Blitz, King George VI and Queen Elizabeth came to the city to inspect the war damage and were accompanied by the Lord Mayor of Portsmouth, Sir Denis Daley, and Lady Daley. They also chatted with nurses, firemen, air-raid wardens, and others who had provided emergency services. The Prime Minister Winston Churchill was another visitor who came to view the devastation for himself. He also took the opportunity to pay a visit to Lord Nelson's HMS *Victory* and is pictured above leaving the ship with Admiral James. The *Victory* can still be viewed in Portsmouth today (*below*).

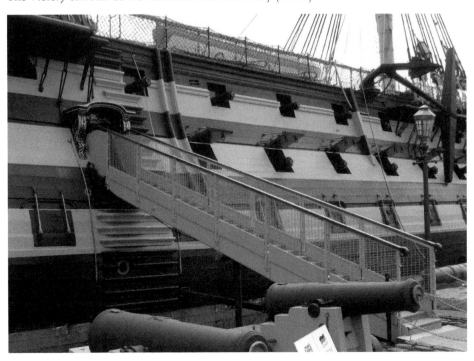

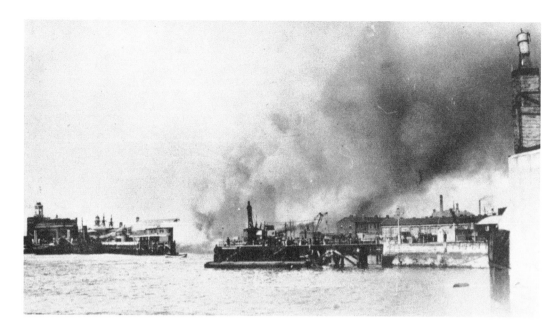

Operation *Overlord*

Throughout the bombing of Portsmouth, the dockyard, seen above during an attack and below in more peaceful times, continued to function, enabling the city to play a vital role when the Allies eventually struck back. Portsmouth has witnessed the departure of many military expeditions but the greatest of these was Operation *Overlord* in June 1944. The city was the main departure point for all units destined for Sword Beach on the Normandy coast. The initial assault involved the British 3rd Infantry Division, a component of the 2nd Army, which encompassed all British and Canadian troops taking part in D-Day.

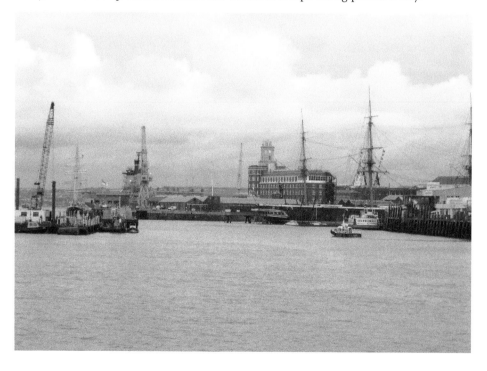

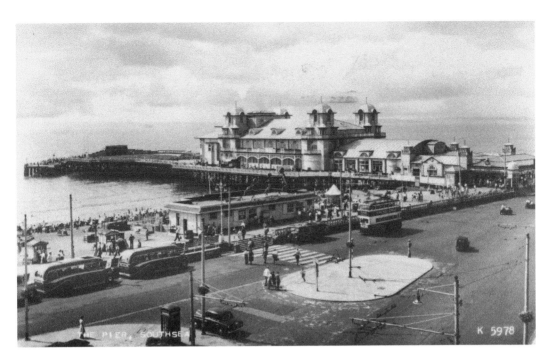

The Build-up Begins

As early as August 1943 parts of the city, including the seafront at Southsea (*above and below*), were declared restricted zones, closed to anybody who didn't have a valid reason to be there. Then on 1 April 1944, the entire city was closed to all visitors, as part of a 10-mile-deep coastal strip from Land's End to the Wash. By this time Hampshire was a huge camp, as men and vehicles moved to their marshalling areas. Taking advantage of the natural woodland cover, the troops camped to the north and east of Portsmouth. These camps were sealed on 26 May so that the final briefings could begin.

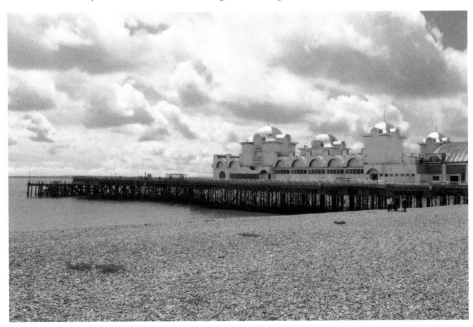

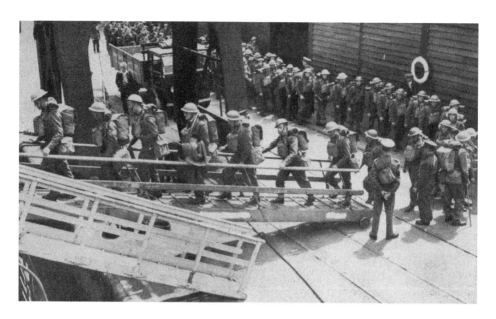

Embarkation of Troops

As D-Day approached, the troops made their way down into the city to be loaded onto waiting boats and landing craft at various locations (*above*), including the naval dockyard, the Harbour, South Parade Pier, and Camber Dock (*below*). As the fleet began to build up in Spithead, it was claimed that, looking down from Portsdown Hill, there were so many ships and landing craft it would be possible to walk from Portsmouth to the Isle of Wight across their decks. Then, on the morning of 6 June, the people of Portsmouth awoke to find this vast armada of ships had gone; D-Day was on.

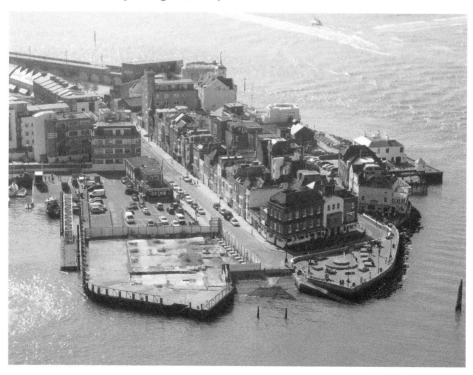

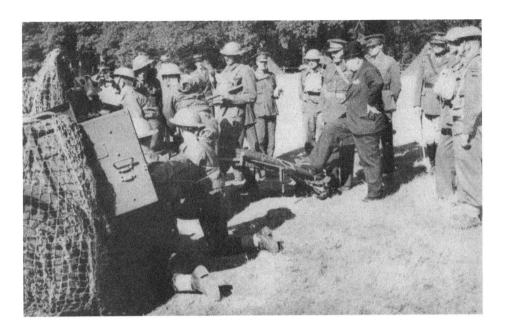

Visiting the Troops

Several places in the area are linked to the story of D-Day, like Southwick House, which was chosen as the HQ of the Supreme Allied Commander, General Dwight Eisenhower. Tunnels beneath Fort Southwick housed the combined operations headquarters, which co-ordinated the progress of the invasion fleet. In Southwick itself, the Golden Lion pub (*below*) became an unofficial officers' mess, where refreshments were served to both Eisenhower and General Montgomery. In the days prior to D-Day, Winston Churchill also visited the troops in Hampshire (*above*) and held last-minute talks with the *Overlord* commanders.

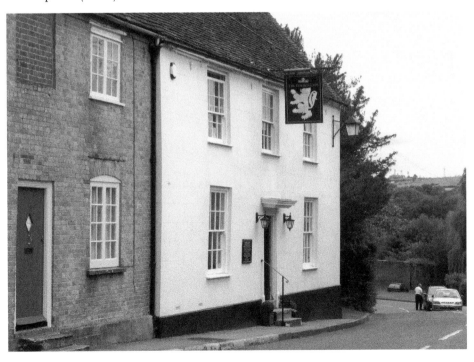

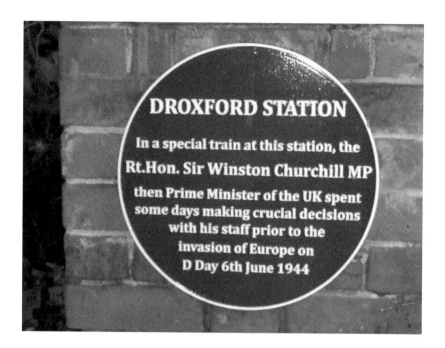

An Unlikely HQ

The Prime Minister arrived by train at the village of Droxford on 2 June 1944 with members of his War Cabinet and leaders from overseas governments. During their stay they used the village railway station (*above and below*) as their headquarters. It is said that Droxford was chosen because of a nearby tunnel. If an air raid occurred the train and its passengers would be driven into the tunnel for safety. On 4 June, General Sir Miles Dempsey and the headquarters staff of the British 2nd Army attended a service at Christ Church in Portsdown, to 'dedicate to almighty God the task which lay before them'.

Gunwharf Quays

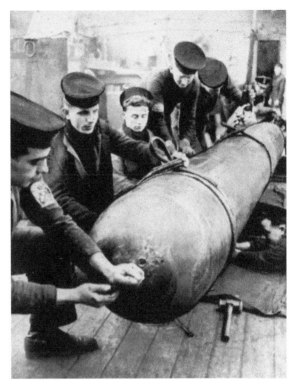

Many visitors to Portsmouth today will be familiar with Gunwharf Quays, the modern shopping centre and marina along the seafront. This whole area was previously the site of the naval shore establishment, HMS *Vernon*. Among other things this was the base for the Motor Torpedo and Motor Gun Boats, which on D-Day protected the flanks of the landings against enemy naval attack. Among the retail outlets there are many reminders of its previous occupation, including several torpedoes, like the Mark VIII 21 inch torpedo (*below*). Above sailors are seen with a similar torpedo on board ship.

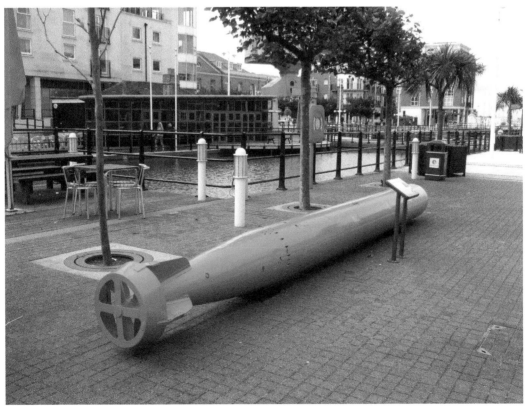

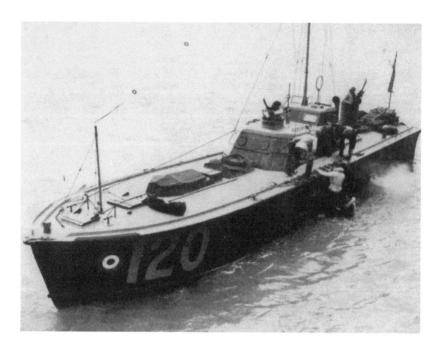

Spitfires of the Sea

Moored at the waterfront you can also see two of the last remaining fully operational Second World War motorboats (*below*), which were nicknamed Spitfires of the Sea. The one on the left is an example of a MGB 81 which was active during the US landings at Omaha beach on D-Day. The other craft is an HSL 102, the only surviving example of the 100 Class high-speed launches which were used at RAF Calshot near Southampton to retrieve shot-down airmen from the sea. These boats reputedly rescued in the region of 10,000 airmen from the waters of the English Channel as illustrated in the photograph above.

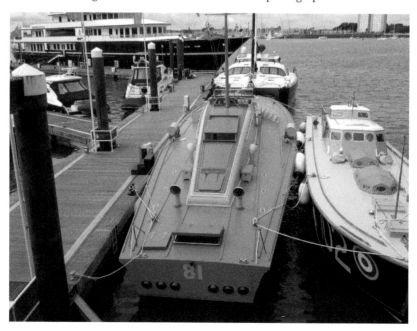

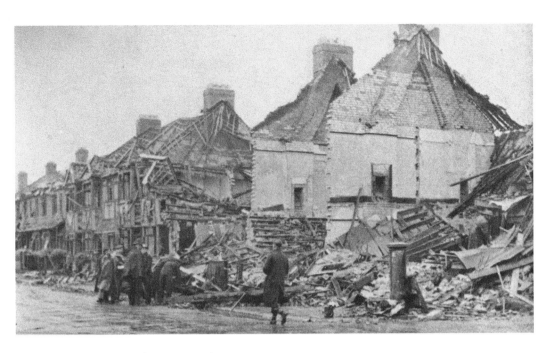

Terror Weapons Hit Portsmouth

Although D-Day and the subsequent invasion had been a success, the bombing of Portsmouth still went on, however not in the conventional sense with the use of aircraft. Six days after D-Day the Germans launched the first of many V-1 flying bomb attacks against Britain. These were indiscriminate terror weapons designed to create panic among the populace. Two of these weapons fell on Portsmouth: the first in Locksway Road (*above*) and the second in Newcomen Road (*below*), which killed fifteen people and injured eighty-two others.

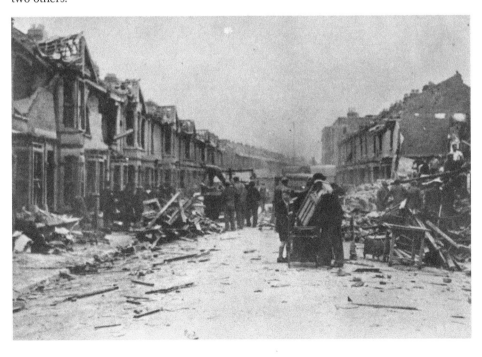

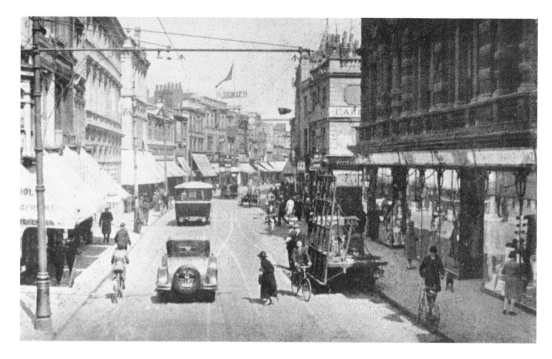

Before and After the Blitz

These photographs show Portsmouth's Commercial Road before and after the Blitz. When the war was over, the need for redevelopment, and the unsympathetic manner in which this was conducted, led to the mismatch of ancient and modern buildings that can be seen around the city today. The Guildhall was rebuilt retaining as much of its original exterior as possible and re-opened in 1959. But much of the city would not be rebuilt until the 1970s. Originally there were grand designs for this re-development but these had to be curtailed due to the austerity that marked post-war Britain.

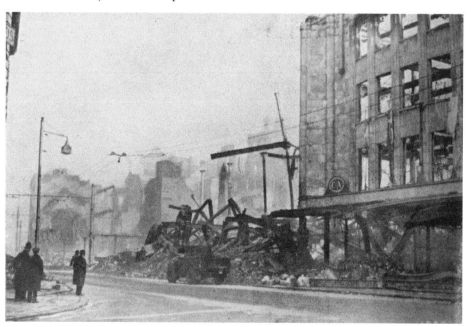

Royal Naval Memorial

There are many monuments around the city that help to remind us of this traumatic period in its history. Paramount among these is Portsmouth's Naval Memorial on Southsea Common. It is one of three identical monuments designed by Sir Robert Lorimer following the First World War. The others are at Plymouth and Chatham. All of these are dedicated to sailors from the naval base in question who were lost at sea and have no known grave. The Portsmouth memorial commemorates almost 15,000 souls who perished during the Second World War.

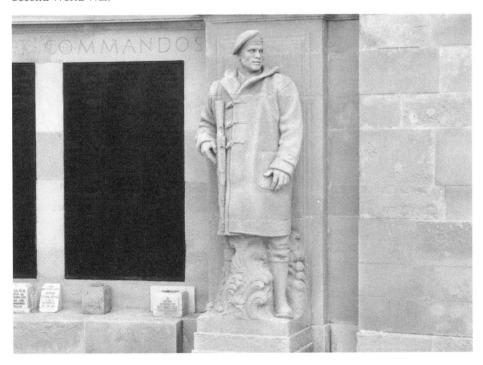

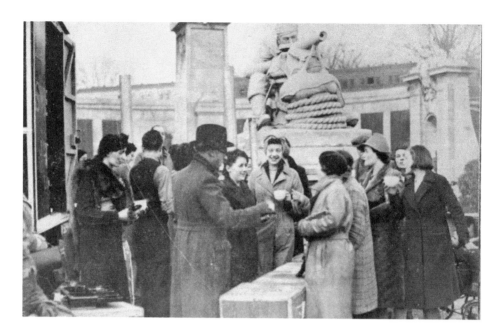

Monuments

In the shadow of the Guildhall, you will find the city's war memorial (*below*), dedicated to servicemen from here that died fighting for their country. The interesting photograph above shows how it was used during the Blitz to provide a space for an open-air canteen. One of the most unassuming tributes is the D-Day memorial on Southsea Esplanade, which was unveiled by Field Marshal Viscount Montgomery of Alamein on 6 June 1948. Monty, who was Portsmouth Garrison Commander from 1937 to 1938 and the most senior British officer on D-Day, is the subject of his own statue along Clarence Esplanade.

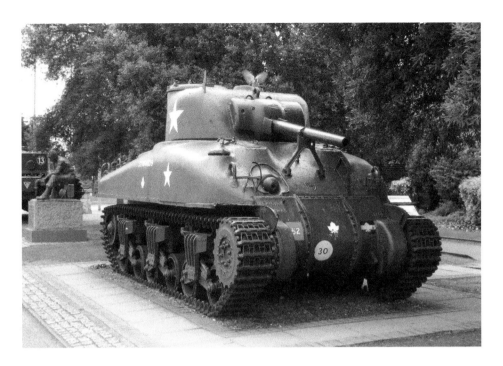

D-Day Museum

Clarence Esplanade is also the location of the D-Day Museum, Britain's only museum dedicated solely to Operation *Overlord*. Queen Elizabeth, the Queen Mother, opened the collection in June 1984 to mark the fortieth anniversary of the Normandy landings. Its centrepiece is the Overlord Embroidery, which, at 272 feet in length, is the world's longest embroidery of its kind. Above and below are a Sherman tank and Churchill tank, respectively, which currently stand outside the main entrance. These were the two main battle tanks employed by the Allied armies throughout the Normandy Campaign.

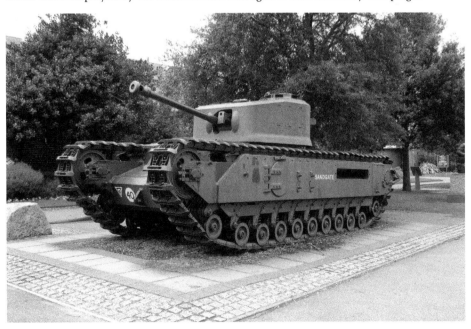

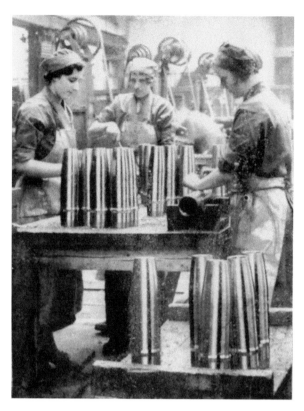

Supplying the Royal Navy

To the west of Portsmouth is Gosport, which during the war played a major role in supplying the Royal Navy with everything it needed. There were three Royal Naval armament depots here, one of which was at Priddy's Hard where some of the original buildings – mostly built in the nineteenth century – can still be seen (*below*). A workforce of around 2,000, mainly women, was employed here doing twelve-hour shifts, preparing and filling shells, torpedoes, mines and other ammunition for the Senior Service (*left*). Today, part of the site houses Explosion! Museum of Naval Firepower.

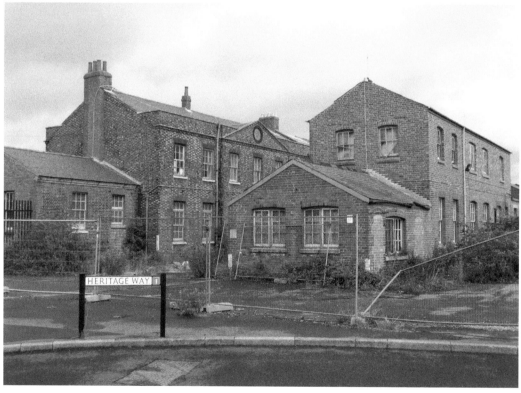

Feeding the Fleet

Food and drink for the Royal Navy were supplied by the Royal Clarence Victualling Yard (*below*), which had its own mill, bakery and slaughterhouse. Without doubt its toughest logistical problem was to supply the fleet assembled at Spithead in the build-up to D-Day. Before the ships sailed, the yard ferried over 20,000 tons of fresh water, hundreds of tons of meat, potatoes and vegetables, and 20,000 lbs of bread (*right*) every day, to the army waiting aboard the vessels. They employed a flotilla of Motor Fishing Vessels, or MFVs as they were known, many of which were made in Gosport by Camper & Nicholsons.

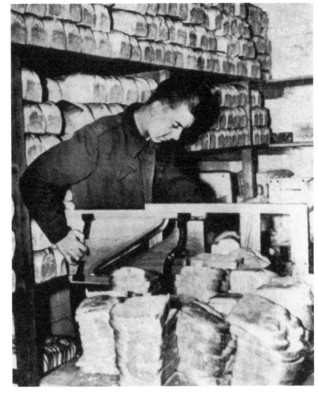

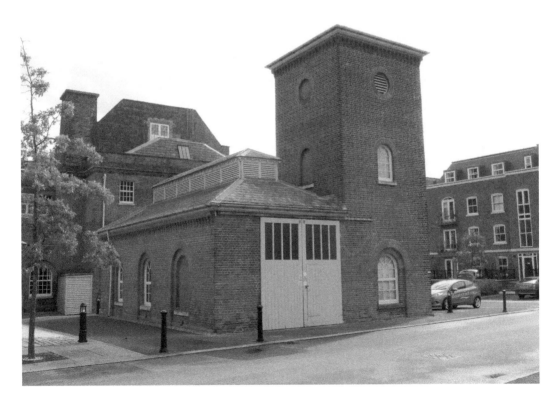

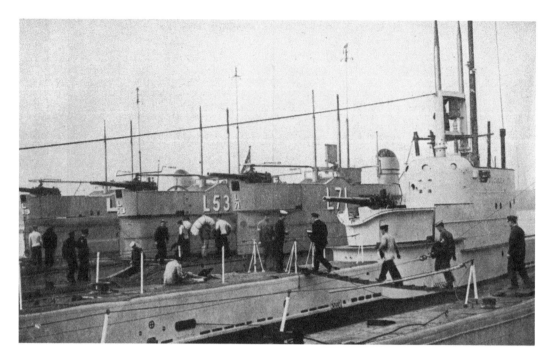

Submarines at Gosport

Gosport also provided the Navy with its main submarine base, HMS *Dolphin*, from where various classes came and went, including two midget submarines that guided the invasion fleet to Normandy by surfacing offshore and signaling with a green light. These two submarines left the base on 2 June, arriving off the French coast two days later. But because of bad weather, which delayed the operation, the crews had to wait in cramped conditions for sixty-four hours. Above, submarines are being boarded at the base. The submarine escape tower seen below was built in 1953, although one had already existed here since 1930.

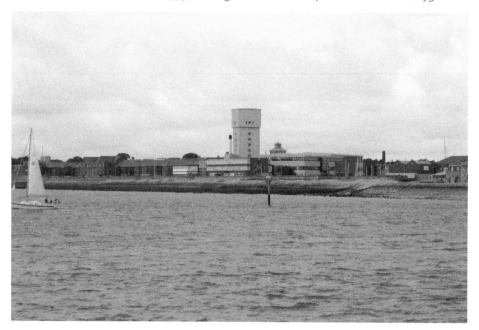

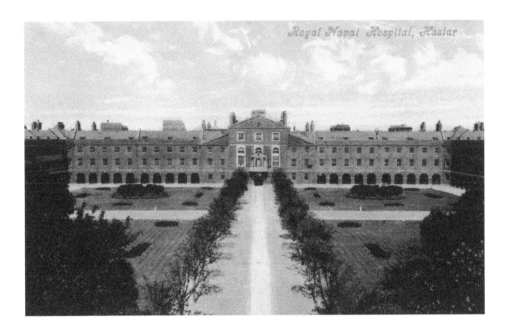

Treating the Sick

Gosport was also the location of the Royal Navy's Haslar Hospital, the wartime role of which was to receive severely wounded casualties from campaigns around the globe. For this purpose the cellars were converted into underground operating theatres. The tower of the hospital is thought to have been used as a navigational aid by the Luftwaffe and although some parts of the complex did suffer bomb damage, the tower itself was left unscathed. After D-Day, Haslar would receive its first casualties on 7 June. Above is an old postcard of the hospital front, with the same scene reproduced below as it appears today.

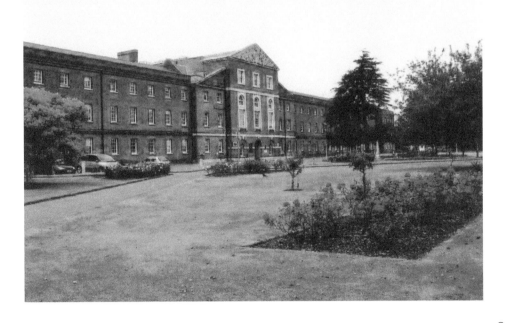

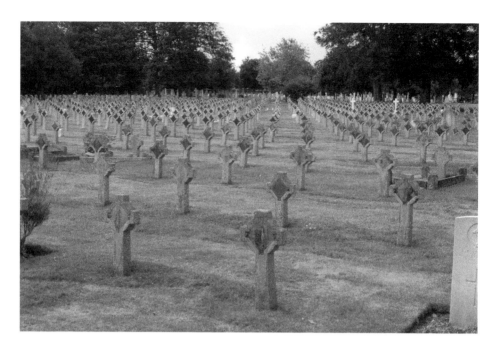

Allied and Enemy Graves

Some of those who didn't survive their wounds are buried in the Haslar Royal Navy Cemetery adjacent to the hospital, others in Clayhall Royal Naval Cemetery, where there are 611 graves dating from the Second World War (*above*). It is also worth visiting Anns Hill Cemetery where there are many more graves dating from this time, including those of German servicemen (*below*). Each grave tells its own story. Unteroffizer Fritz Budig for instance was only twenty-six when his Messerschmitt Bf 110 was shot down into the sea at Spithead on 12 August 1940 at the height of the Battle of Britain.

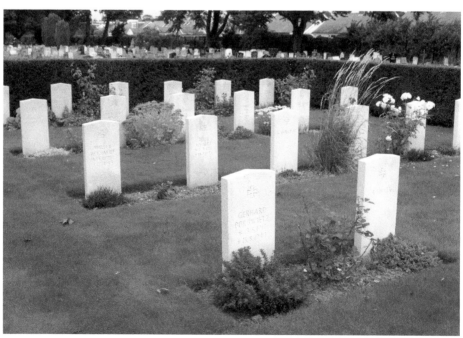

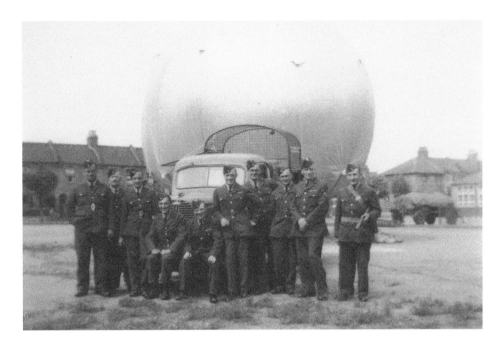

Barrage Balloon in Forton Road

The town of Gosport itself suffered considerable bomb damage during the Blitz of 1941, with more than half of its houses reputedly being damaged. In Ann's Hill Cemetery you will find a memorial stone dedicated to all those who died, while the stone seen below commemorates ten servicemen and two civilians who died when a barrage balloon site in Forton Road took a direct hit on 12 August 1940. The photograph above shows a mobile balloon winch tender, as used by the RAF to ferry barrage balloons to sites around Gosport, as well as Portsmouth, Southampton and other large conurbations.

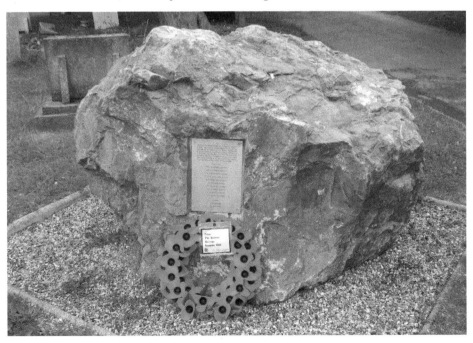

D-Day Hards

Similar to Portsmouth, Gosport was also a major embarkation centre for D-Day. Roads were hardened along Stokes Bay, to make it possible for lorries and armoured vehicles to embark from here. At Hardway the concrete ramps that were built in order to load vehicles onto landing craft can still be seen (*above*). From here further British and Canadian troops would depart for Normandy. In the following weeks thousands of German prisoners would be disembarked at Hardway and then, either marched directly to the train station, or to a holding camp in Mill Lane. Below is the D-Day memorial at Stokes Bay.

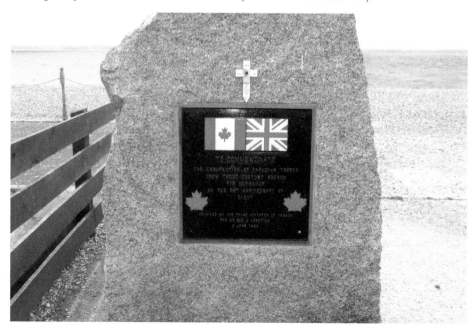

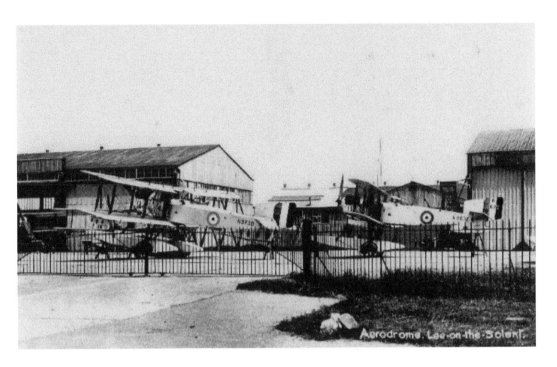

Aerodrome, Lee-on-the-Solent.

Naval Fliers at Lee-on-the-Solent

A little further along the coast at Lee-on-the-Solent, the Royal Naval Air Service had an air station known as HMS *Daedalus*, seen above in the 1930s. Its wartime role was mainly one of training naval aviators and aircrew, although the Royal Navy did house many of its Swordfish torpedo bombers here as well. In the early stages of the conflict it was also used to accommodate various types of seaplane. Below we can see some of the original hangars, a few of which now house the Hovercraft Museum, a unique international collection.

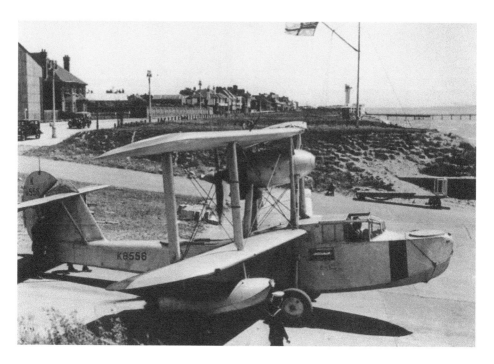

Air Cover for the Invasion

In the photograph above, a seaplane is being taken to the waterfront at Lee-on-the-Solent down the slipway, the remains of which can be seen in the picture below as it appears today. Before D-Day the airfield was crowded with Supermarine Spitfires, Supermarine Seafires, and North American P51 Mustangs of both the RNAS and the RAF. Their job was to ensure that enemy aircraft did not approach the area and in so doing discover the full extent of the Allied preparations. During Operation *Overlord,* 435 sorties were flown from here providing air cover for the invasion fleet as it crossed the Channel.

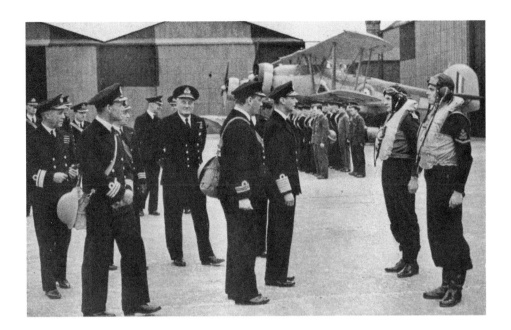

A Royal Visitor

In the picture above, in which Swordfish aircraft can be seen in the background, King George VI visits the base at Lee-on-the-Solent in July 1940. The repair and overhaul of these naval aircraft was carried out at Fleetlands just to the north of Gosport. Although HMS *Daedalus* was closed by the MOD in 1996, the airfield itself remains active, now under civilian management (*below*). Along the seafront at Lee-on-the-Solent you will also now find the Fleet Air Arm Memorial, dedicated to naval airmen who died serving their country in the Second World War.

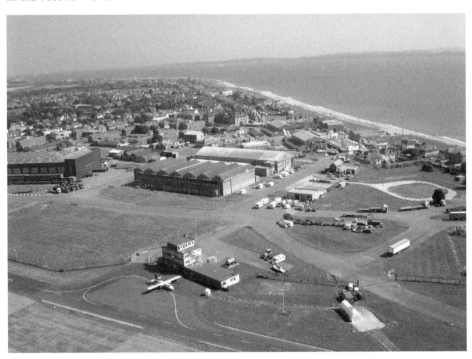

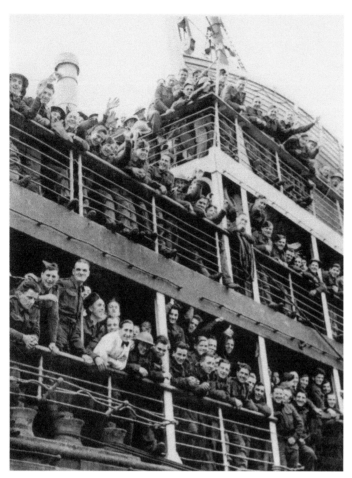

The British Expeditionary Force

Throughout its history the county's largest city, Southampton, has been an embarkation point for troops departing for wars around the globe. The Second World War was no exception, as it was from here that the British Expeditionary Force was shipped to France at the start of hostilities (*left*). The BEF was a home-based regular army created in 1938, most of whose soldiers were garrisoned at Aldershot under the command of Lieutenant-General Sir John Dill. It would enable Britain to respond quickly if war did break out with Germany. Below we see the Gordon Highlanders at Aldershot shortly before embarkation.

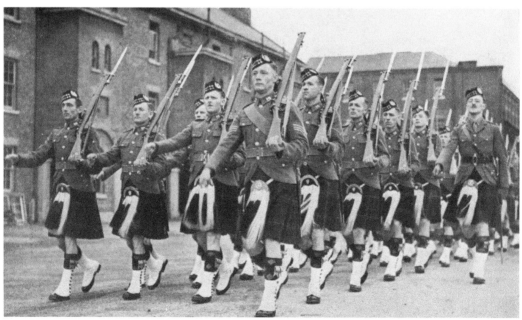

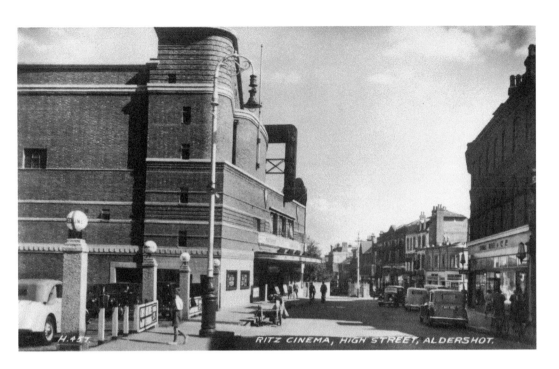

RITZ CINEMA, HIGH STREET, ALDERSHOT.

A Military Town

As well as being the site of one of Britain's biggest wartime garrisons, Aldershot was in every sense a military town. Originally a small village, it grew into a sizeable town where the facilities revolved around the military personnel and their families who frequented them, after the War Department purchased land nearby to establish a permanent Army training camp in 1854. The photographs, above and below, of the Ritz Cinema in the High Street and the post office in Victoria Street were taken in the late 1930s, so give a good impression of how the town looked during the war years.

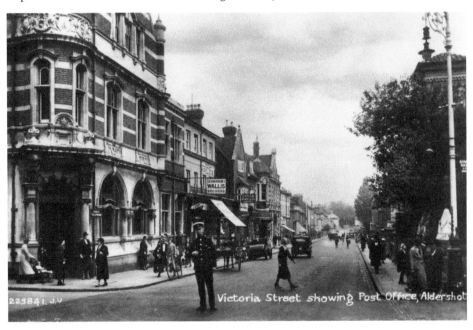

Victoria Street showing Post Office, Aldershot

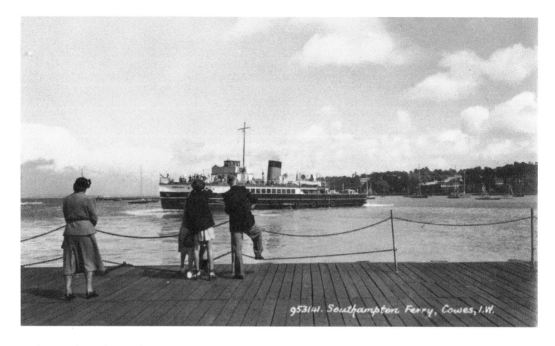

953141. Southampton Ferry, Cowes, I.W.

Red Funnel Ferries to the Rescue

The first ships left Southampton on 9 September 1939 and by March 316,000 men had been transported to France and Belgium. In May the Germans attacked the Allied front, leading to the evacuation of the BEF from Dunkirk. Vessels from Southampton sailed to the rescue, including Red Funnel Ferries, which would normally take passengers to the Isle of Wight. Above, a Red Funnel ferry is seen sailing between Southampton and Cowes. Below is the *Calshot* being restored in Southampton Docks. She was mainly used on the Clyde, transferring troops from ships to shore, returning to Southampton in time for D-Day.

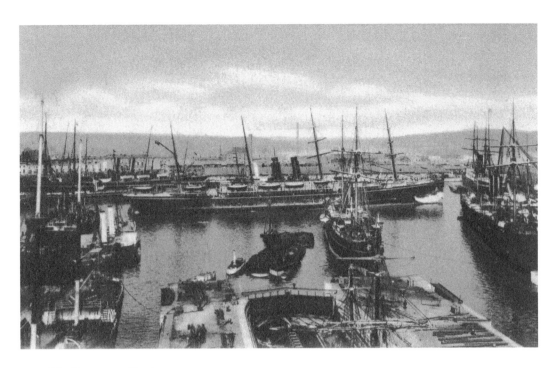

The Passenger Trade

Because of its docks and a number of important industries, similar to Portsmouth, Southampton would suffer badly during the war from large-scale bombing raids. But ironically, although the docks had been a traditional embarkation point for the British Army, they had relatively little other military significance. Their peacetime business was largely passenger trade, as they were a major terminal for ocean-going liners, such as the White Star, Cunard and Union Castle lines. They also processed a certain amount of cargo traffic. Above we see the docks in the early twentieth century and below as they appear today.

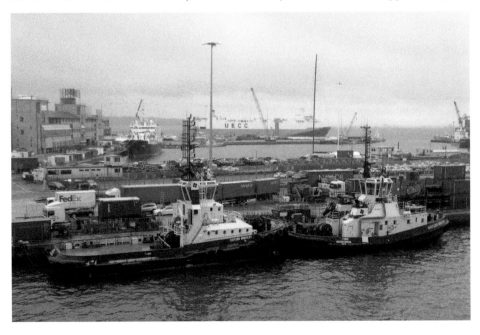

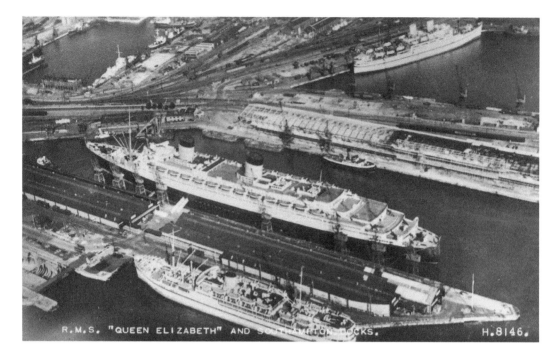

R.M.S. "QUEEN ELIZABETH" AND SOUTHAMPTON DOCKS. H.8146.

RMS *Queen Elizabeth*

Above, the RMS *Queen Elizabeth* is seen docked at Southampton. She was a liner that operated between Southampton and New York. Her maiden voyage was planned for April 1940 but the war changed everything and she was requisitioned as a troopship and sent to Singapore. She carried Australian troops to war zones in Asia and Africa before relocating to the North Atlantic in 1942 to ferry American troops to Britain. She transported over 750,000 troops before finally entering service with Cunard. Below, one of her descendants, Cunard's *Queen Mary 2*, in Southampton Docks in 2010, before sailing for New York.

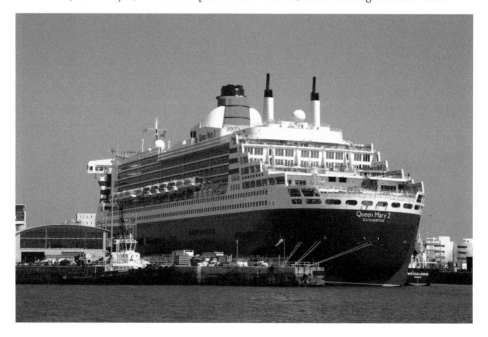

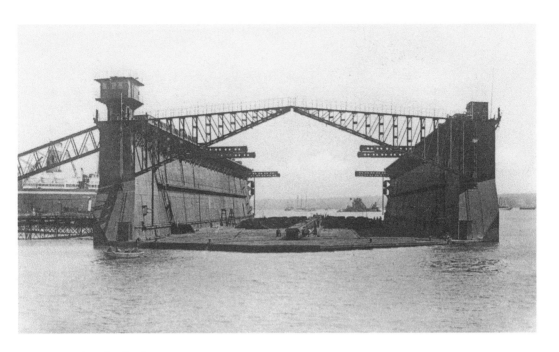

Targeting the Docks

When the war began the government decided that Southampton Docks would be too risky a place to be used by the valuable merchant convoys that brought food and other supplies into the country. Much of the equipment was transferred to other ports and the majority of registered dockworkers, who were in reserved occupations, were relocated to more active places. Above we see Southampton's famous floating dock, which was moved to Portsmouth. Even so, the docks still had their share of significant attacks. The Solent Flour Mill (*below*) and the Royal Pier were among notable buildings that suffered from direct hits.

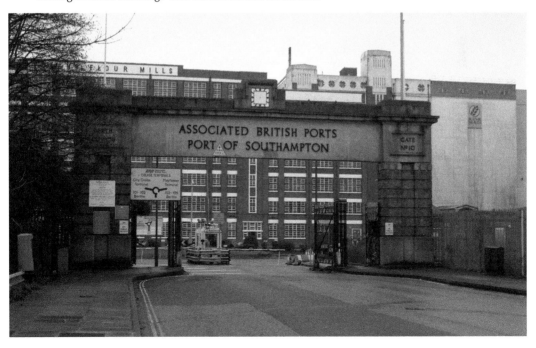

Shipbuilding at Itchen

One of the city's largest industries, the John I. Thornycroft shipyard was located on the east bank of the River Itchen at Woolston. Here the first Landing Craft Assaults (LCAs) were built for the Royal Navy, such as the example seen above. By 1944 sixty of these were being built each month, many of which would be used on D-Day by the Allied forces. As well as these, Thornycroft built a huge and diverse number of ships during the war, from minesweepers to destroyers. The photograph below shows the Vosper Thornycroft site in 2005. The site is now being redeveloped for housing and other purposes.

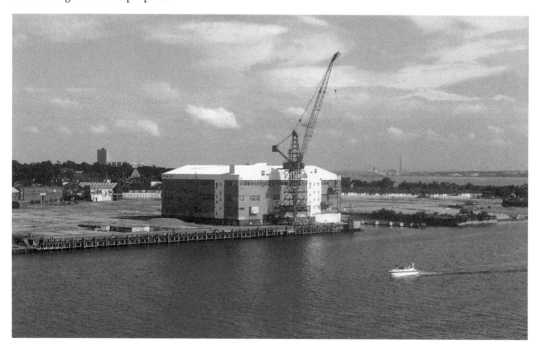

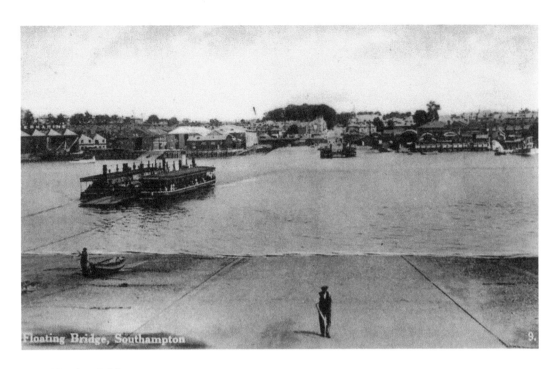

Floating Bridge, Southampton

9.

Floating Bridge

During the war, although the John I. Thornycroft shipyard was bombed several times, the Luftwaffe's main target in the area was its near neighbour, the Supermarine Aviation Works. The pre-war photograph above, and the same scene below in 1976, show the floating bridge that operated between Woolston and Southampton from 1836 to 1977. The Thornycroft shipyard can be seen on the right of the photographs and Supermarine to the left. The floating bridge was a cable ferry which was discontinued when the Itchen Bridge was opened, which now spans the river at roughly the same location.

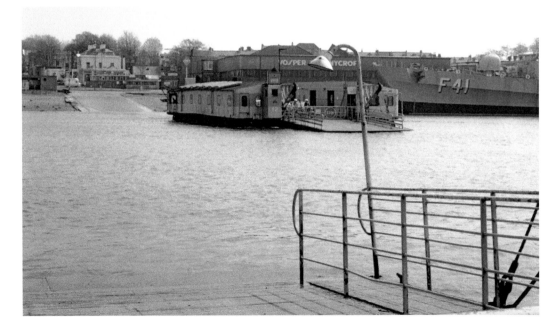

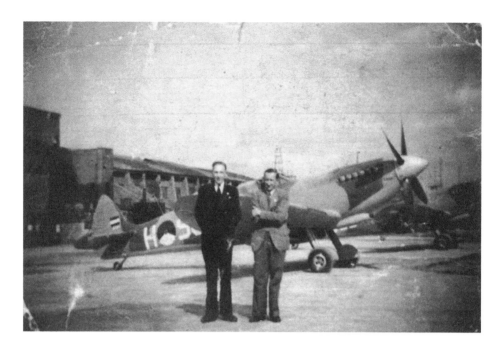

Spitfire Manufacturing Around Southampton

Supermarine was an aircraft manufacturer whose head designer, R. J. Mitchell, was responsible for the Spitfire, variants of which were being built in the company's factories at Woolston, Itchen, or the site of Southampton airport near Eastleigh, which during the war years was a Naval air station known as HMS *Raven*. In fact it was here that the prototype Spitfire K5054 was first flown on 5 March 1936. The photograph above was taken at Eastleigh in the late 1940s and shows Bert Bosanquet and Bill Tucker, who both worked there on Spitfires. Below is a replica of Spitfire K5054 as you approach Southampton airport today.

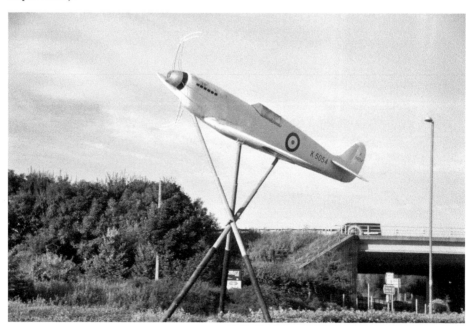

Bombing of the Supermarine Factories
In September 1940 the Itchen and Woolston factories were severely damaged in air raids that left over 100 workers dead. As a result Spitfire production was dispersed around other engineering companies, with each making different components. It was eventually spread over sixty-five units, which between them built over 85,000 aircraft. To the right we see female workers who worked on Spitfires at the Auto Metal Craft factory in Southampton. Below, an aggregate company now using the old Supermarine site at Woolston. The only indication of its former use is the slipway that was used by amphibious aircraft.

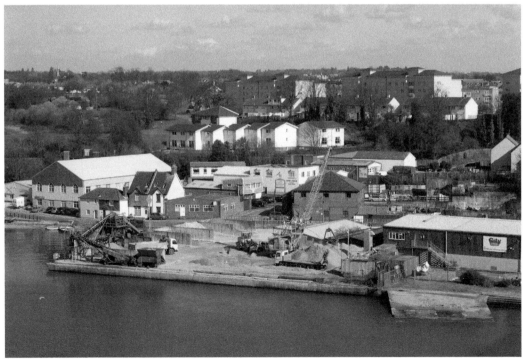

Spitfire Assembly Units

As well as factories there were assembly units, where all the various parts were brought together to construct battle-ready aircraft (*above*). One of these was located at Chattis Hill, 2 miles west of Stockbridge. Along the A30, the sign below for 'Spitfire Lane' leads you to woods in which assembly sheds were built, well hidden from prying eyes. When the aircraft were fully prepared they were taken to the site's grass airstrip and flown away by women pilots of the Air Transport Auxiliary. Supermarine commenced operations here in December 1940, with the first aircraft delivered out in March 1941.

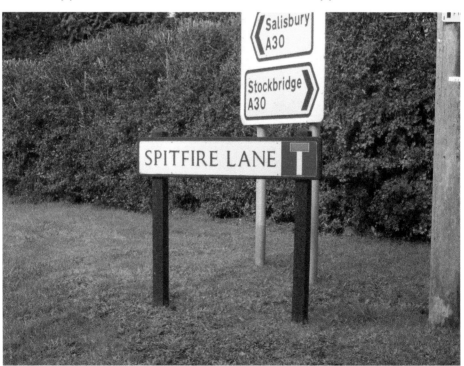

Other Aircraft

Supermarine also produced other aircraft during the war, perhaps the best known of which was the life-saving Walrus (*above*). This amphibian was largely used for air-sea rescue and was responsible for retrieving ditched Allied airmen. After the Blitz the company moved its headquarters and design staff to a large country mansion near Winchester, called Hursley House (*below*). In 1943 the Admiralty requisitioned the bombed-out remains of the factory at Woolston to provide a base for the planning of PLUTO, an undersea pipeline that supplied petrol to the invasion forces after D-Day.

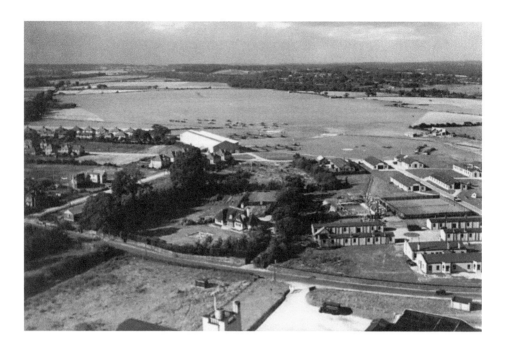

Hamble Airfield

Several pipelines would be laid across the English Channel, including one from the Isle of Wight, which was supplied from the BP oil terminal at Hamble-le-Rice. On Hamble beach today you can see the anti-aircraft gun emplacement, pictured below, mounted by a Bofors gun. Inland was an airfield (*above*), where Avro, followed by Armstrong Whitworth, had aircraft factories. At one point this was the leading repair facility for Spitfires. Wrecks would be refitted here and flown back to operational squadrons by female members of the Air Transport Auxiliary, who were permanently based at the airfield.

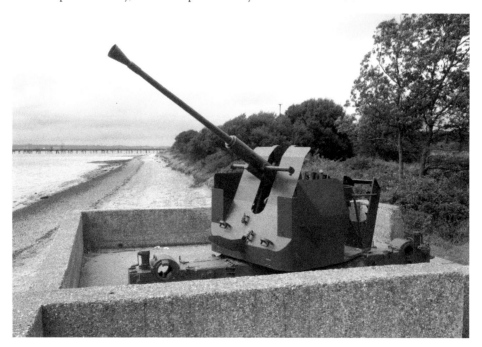

ATA Memorial

On 10 July 2010 the memorial pictured below was unveiled 'in honour of the courageous men and women of the Air Transport Auxiliary' on the occasion of the seventieth anniversary of the Battle of Britain. It stands on the spot that was once the entrance to the ATA ferry pool at Hamble-le-Rice airfield, which by 1941 had become an all-female unit. To the right is a portrait of a young ATA flier. The ATA was formed at the outbreak of the war to transport mail, dispatches, and essential supplies, but quickly developed to ferry new, damaged, and repaired aircraft between the aviation industry and the RAF and Fleet Air Arm.

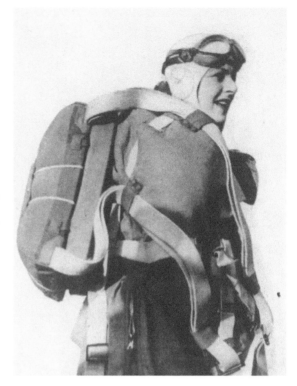

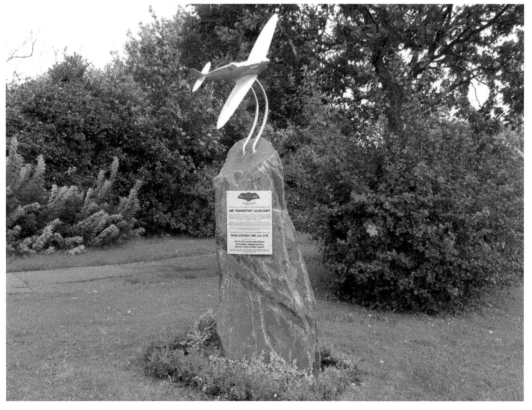

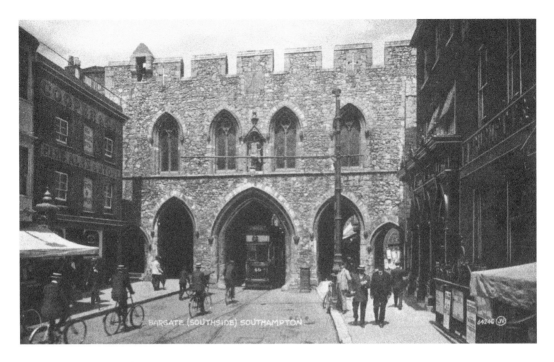

Southampton Blitz

There were fifty-seven air attacks on Southampton in total and, according to ARP records, over 2,600 bombs were dropped, amounting to over 470 tonnes of high explosives, as well as over 30,000 incendiary devices. Of the raids, by far the worst took place on 23 and 30 November and 1 December 1940. These attacks are collectively known as the Southampton Blitz. Some 40,000 buildings were damaged, with 5,589 destroyed. The high street and main shopping areas were devastated. Above is the Bargate, one of Southampton's best-known historic features, before the war and, below, how the scene appears today.

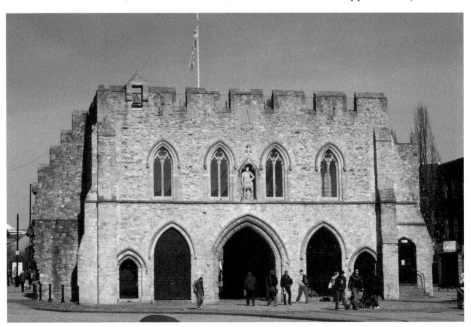

Many Sad Losses

Seven churches, including the one in the photograph on the right, were destroyed. These included Holyrood, seen below today, the remains of which are dedicated to merchant sailors who lost their lives at sea. Also hit was the Ordnance Survey Department. Ironically this had been moved to Southampton after fire destroyed its offices at the Tower of London. One tragic event took place on 6 November 1940, when a 500-lb bomb fell on the Arts Block at the Civic Centre at around 2.45 in the afternoon. More than thirty people were killed, fourteen of whom were children who had taken refuge inside an air-raid shelter.

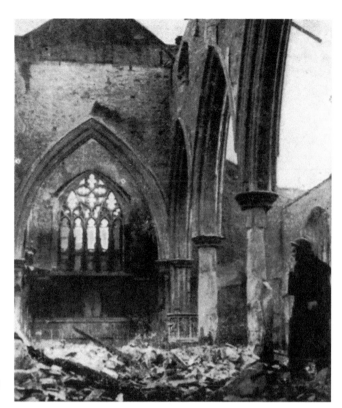

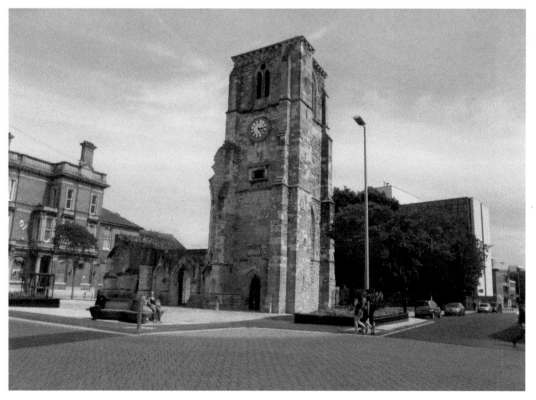

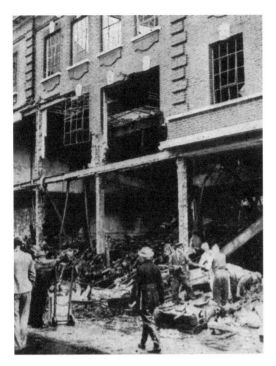

Doodlebugs Target the City

Similar to Portsmouth, Southampton was later rocked by V1 flying bombs. In fact it was the target of the very first V1 attack on Britain on 13 June 1944. In all, around fifty 'doodlebugs' are believed to have been aimed at the city, although only a handful actually hit the mark. The bombing of Southampton would eventually leave 630 civilians dead, 898 seriously injured, and nearly a thousand more with varied wounds. The photograph on the left was taken in Southampton during the Blitz, while the memorial below is one of several around the city dedicated to people who died in the bombing.

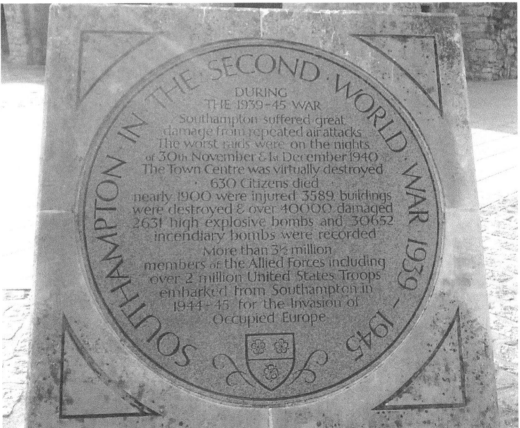

SOUTHAMPTON IN THE SECOND WORLD WAR 1939 – 1945

DURING
THE 1939–45 WAR
Southampton suffered great
damage from repeated air attacks
The worst raids were on the nights
of 30th November & 1st December 1940
The Town Centre was virtually destroyed
630 Citizens died
nearly 1900 were injured 3589 buildings
were destroyed & over 40000 damaged
2631 high explosive bombs and 30652
incendiary bombs were recorded
More than 3½ million
members of the Allied Forces including
over 2 million United States Troops
embarked from Southampton in
1944–45 for the Invasion of
Occupied Europe

Preparing the Docks for the Invasion

In 1943 the docks were taken over by the Americans to arrange the shipping and supply of equipment and troops during the forthcoming invasion. In the first few months after their arrival, they moved so much military cargo that Southampton became the third-largest importing centre in the world. This was of course all building up to D-Day and soon the docks were filling up with jeeps, tanks and other equipment belonging to the American First Army. The picture above shows American troops in Southampton waiting for D-Day to arrive while, below, the submarine HMS *Astute* can be seen in the modern docks.

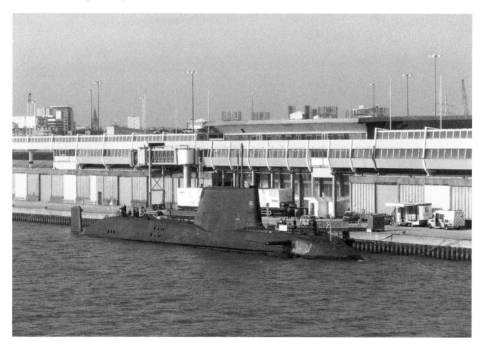

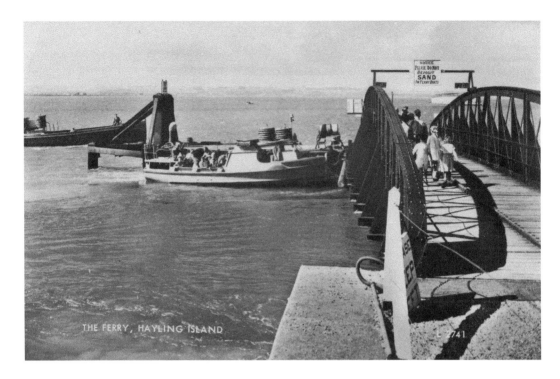

The Ferry, Hayling Island

Mulberry Harbours

Sections of the Mulberry Harbours were also constructed here. In fact, although twenty-six bases around Britain contributed to this top-secret project, Southampton was the main centre of activity. Components made elsewhere were brought to the port for assembly and, once completed, these floating harbours were moored off Selsey Bill and Dungeness until they were needed along the Normandy coast. Several sections were built near the ferry landing on Hayling Island, seen above in the late 1950s. One of these developed a crack and had to be abandoned. It can still be seen lying off Ferry Point to this day (*below*).

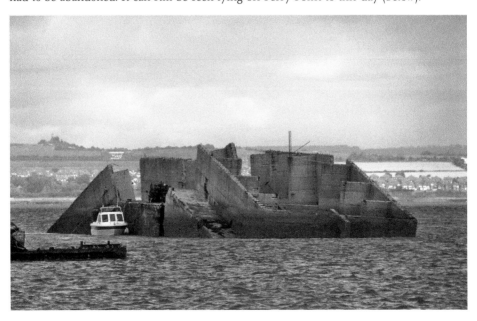

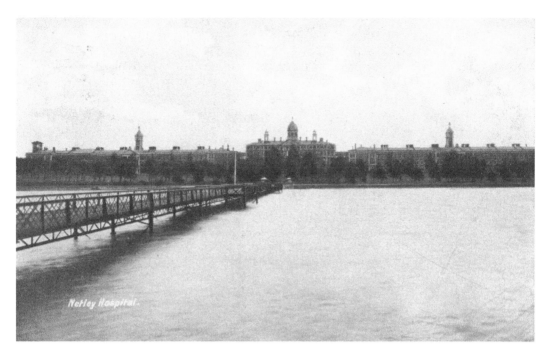

Netley Hospital.

Build-up of Troops

As the pivotal day drew nearer a large force of American troops began to appear right across the city. Convoys of parked vehicles blocked the roads from the city centre to places like Shirley and Bitterne. Schools, warehouses, hotels, and hospitals were all turned into billets, including the Royal Victoria Military Hospital at Netley, the largest military hospital ever built, pictured above in its heyday. All that remains of the hospital today is the chapel, seen below, which now houses many wartime exhibits. Eventually the whole of Southampton Common became an enormous American camp.

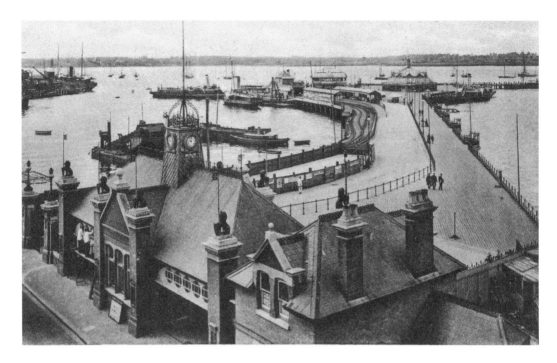

Southampton's D-Day

On 3 May 1944 the troops in Southampton took part in Exercise *Fabius*, the largest amphibious training exercise of the war and the final dress-rehearsal for D-Day. A month later the Americans would leave Southampton again, this time bound for the actual beaches of Normandy. In the following months over 3.5 million men would pass through the port along with 11 million tonnes of cargo. Over 228,000 wounded GIs would be processed back through Southampton, and over 194,000 prisoners of war, who would mainly disembark at the Royal Pier, seen above in a pre-war postcard and below today.

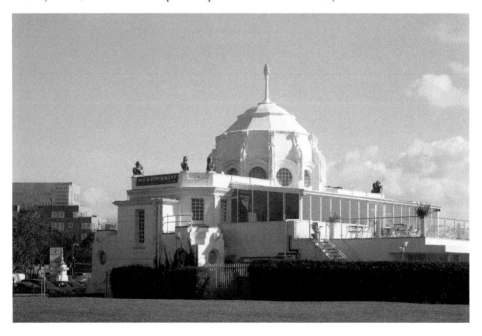

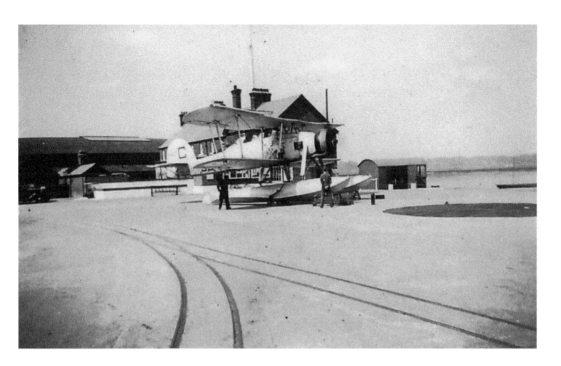

The Schneider Trophy

On the opposite bank of Southampton Water was the former RAF Calshot, pictured above pre-war. Although this was principally a base for seaplanes, it had a strong connection with the development of the Spitfire. Among other things it was the home of the RAF's High Speed Flight, as it prepared to compete for the Schneider Trophy, an international race for seaplanes held bi-annually. In 1927 the competition was held in Venice, and won for Britain by a team from Calshot in a Supermarine S.5, designed by R. J. Mitchell. Below, the Prince of Wales is seen at Calshot in 1929 with an Italian team aircraft.

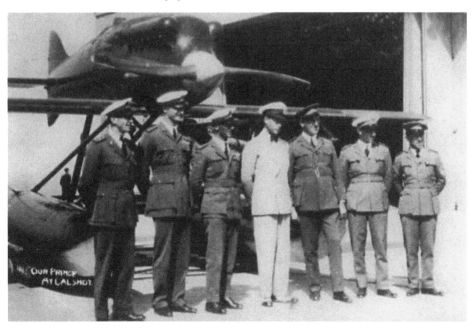

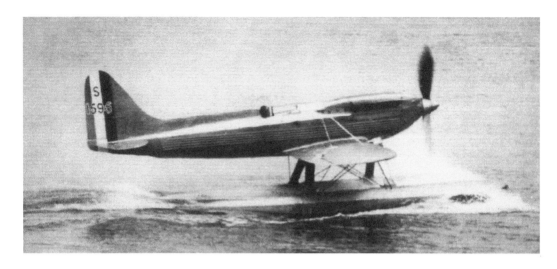

World Speed Record

Britain won the right to host the event in 1929 and Calshot was chosen as the venue. It was won again by an updated S.5. Two years later, also at Calshot, the Supermarine S.6B (*above*) won the race for Britain for the third time in a row, and in doing so retained the trophy outright. Although this would prove to be the final contest, Supermarine continued to develop the S.6B, and with it consistently broke the world speed record, until in September 1931 it became the first craft of any description to break the 400 mph barrier. The building below, which has a bas-relief of the S.6B on the side, was once the officers' mess.

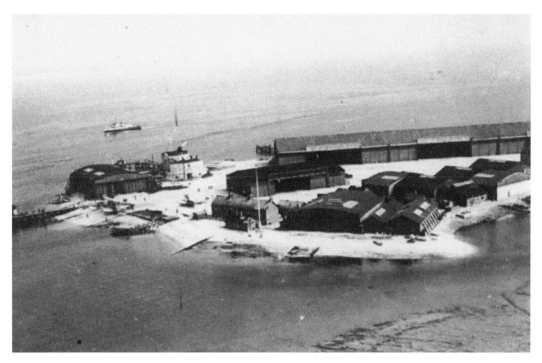

Birth of the Spitfire

If you study the design of these early Supermarine seaplanes, you can already begin to see the emergence of the Spitfire, so when the Air Ministry asked the company to design a new fighter aircraft, Mitchell went back to his Schneider Trophy-winning seaplanes as a starting block; the rest is history. Sadly, Mitchell died from cancer in June 1937, so he never got to realise the enormity of his work, or the huge impact it would have in helping to defend Britain during its darkest hours. Above is another view of the airfield at Calshot and on the right, R. J. Mitchell can be seen at the base on the right of the photograph.

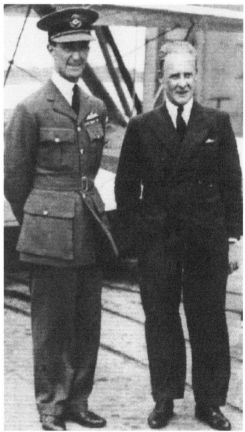

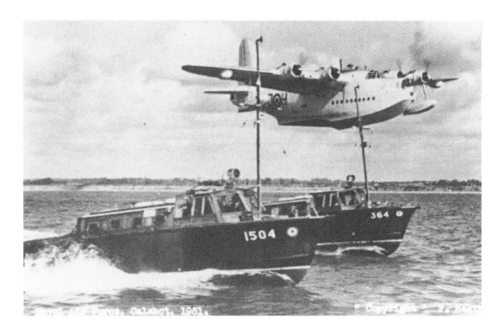

Flying Boats and Rescue Launches

RAF Calshot was primarily responsible for the repair and maintenance of flying boats and concentrated on the Short Sunderland. It also provided maintenance for RAF Search and Rescue vessels. The photograph above shows both a Sunderland and rescue launches from Calshot. From May 1942, the station was largely given over to air-sea rescue, and both aircraft and launches operated from here. A number of these small boats took part in D-Day, being positioned off the beaches in readiness to rescue downed aircrew. The building seen below was a huge hangar for Sunderland aircraft.

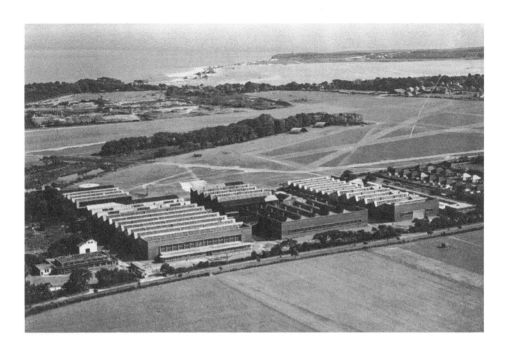

Airfields of the New Forest

Travelling west from Calshot you enter the area of Hampshire known as the New Forest, where reminders of wartime activity are still plentiful in the landscape. At the height of the war, for instance, there were no less than twelve airfields and advanced landing grounds in the area, all of which are listed on the memorial below at the site of the former RAF Holmsley South, including Christchurch pictured above. It is dedicated to all servicemen and women from home and abroad who were stationed in the New Forest during the war.

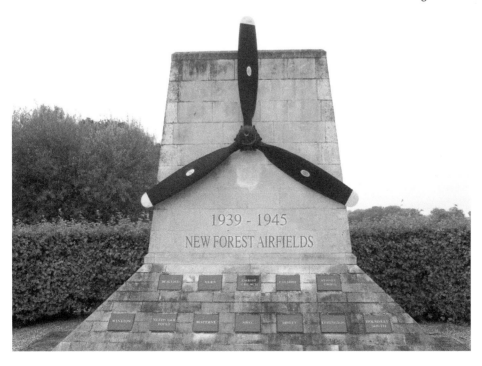

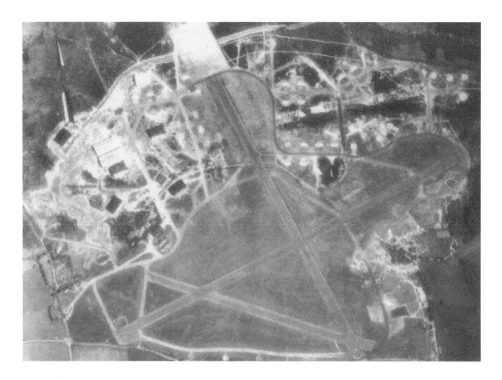

Changing Counties

Some of the New Forest airfields, such as Hurn (*above*) and Christchurch (*below*), although in Hampshire during the war years, are now within Dorset following the redefinition of the county boundaries in 1974. Of the examples that remain in the county of Hampshire today, most followed a similar pattern, first operated by the RAF, as either fighter or bomber stations, then given over to the Americans in time for the invasion, before being returned to the RAF again, following D-Day. One example of a New Forest airfield was RAF Beaulieu near the village of East Boldre, which was opened in August 1942.

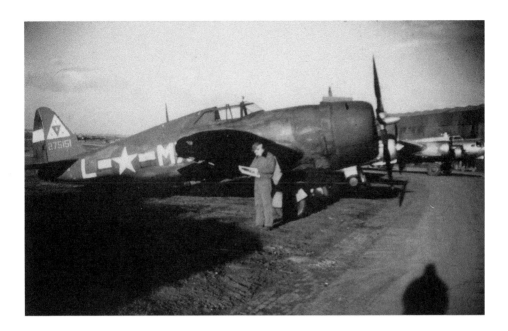

RAF Beaulieu

RAF Beaulieu was initially used by RAF Coastal Command for anti-submarine patrols. From here the crews of Consolidated B-24 Liberators in RAF service, or Handley Page Halifaxes, hunted for German U-boats in the Bay of Biscay. But it wouldn't be long before the site was required in support of the forthcoming invasion. In March 1944 the airfield became United States Army Air Force Station 408, and the Republic P-47 Thunderbolts (*above*) of the 365th Fighter Group of the Ninth US Air Force took up residence. The picture below shows the remains of an air-raid shelter at the base.

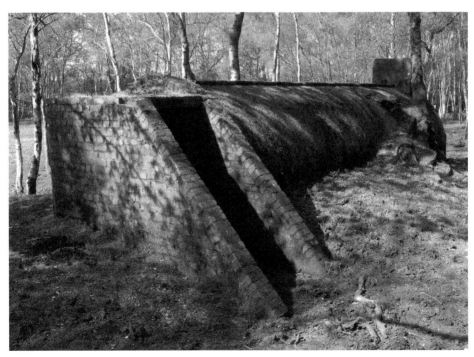

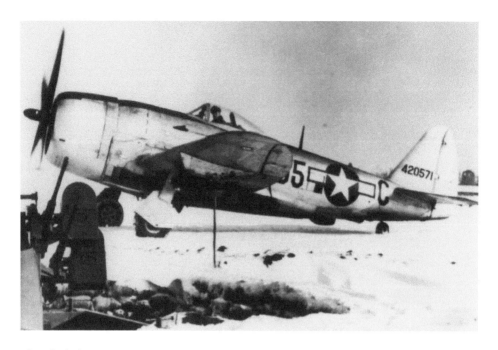

Thunderbolts

The 365th Fighter Group would operate in a ground attack and fighter-bomber role, targeting bridges, aerodromes, railways, and weapon sites, prior to the invasion. On D-Day their duties were to attack gun emplacements and communications facilities behind the bridgehead. Two P-47s were lost, with another five the next day. In combat against other aircraft, the 365th was one of the most successful Thunderbolt groups in the American Air Force. During a four-month stay at Beaulieu they accounted for twenty-nine enemy aeroplanes. Above is one of the group's Thunderbolts and below, another ruin at the airfield today.

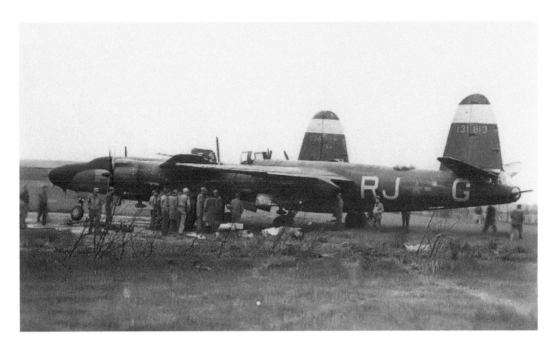

Marauders

In time Beaulieu airfield exchanged fighters for bombers with the arrival of the 323rd Bombardment Group, which would fly Martin B-26 Marauders deep over enemy-held territory (*above*). They flew twenty-eight missions from Hampshire without loss, although one B-26 did crash-land near the airfield after running out of fuel. In December 1944, back in British hands, the Airborne Forces Experimental Establishment moved to the airfield and would see out the war conducting trials in glider-towing and parachute-dropping. Below are some of the concrete roads and bases of buildings still evident at the site.

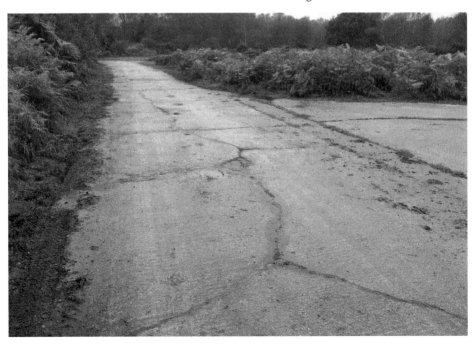

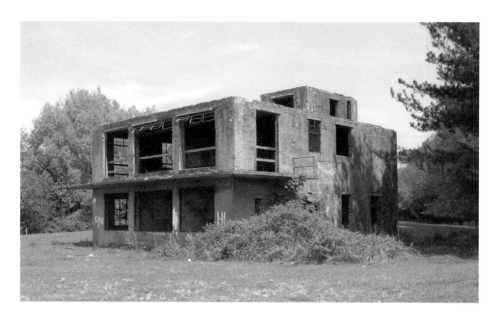

First of the Few

At the sites of other New Forest airfields, such as Stoney Cross or Ibsley (*above and below*), there are still remains in varying states of decay, each of which will give you an evocative taste of what must have gone on there around seventy years ago. In 1942 RAF Ibsley was used for the location shots in the film *First of The Few* starring David Niven, which told the story of the development of the Spitfire and the pilots who flew them. R. J. Mitchell was played by Leslie Howard, who would tragically die in 1943 himself, when the airliner in which he was a passenger was shot down by the Luftwaffe into the Bay of Biscay.

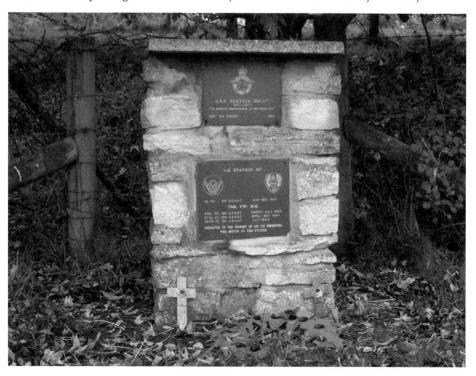

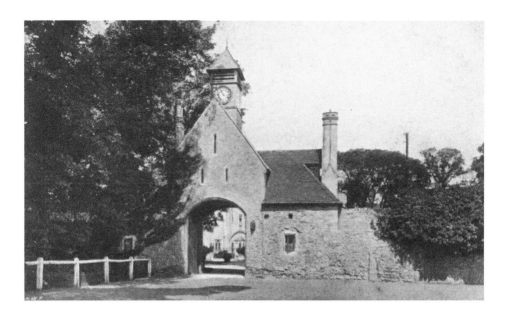

The Beaulieu River

But airfields aside, the whole area around the Beaulieu River was a hive of activity. Large houses along its banks were used by clandestine organisations, such as commando units, while agents of the Special Operations Executive (SOE) employed the Palace House at Beaulieu Abbey for a training base. Above is a pre-war view of the gatehouse to Beaulieu Abbey, with the scene replicated in the photograph below. Scientists worked on the mud flats downriver, experimenting with rocket launchers, and before the invasion, over 500 landing craft accumulated here.

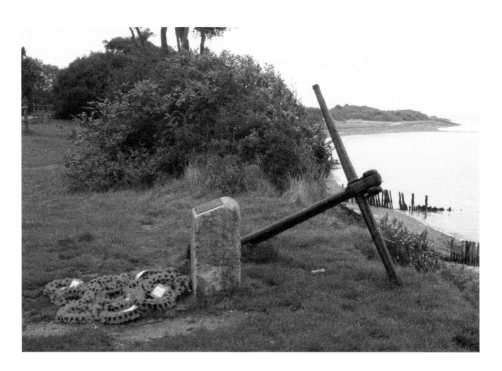

D-Day Reminders at Lepe

The anchor (*above*) in the Lepe Country Park is dedicated to the memory of all those who gave their lives on D-Day. The two bollards (*below*) were used for securing ships during the loading of supplies and troops. In the sea are two iron structures that are all that now remain of a jetty that was used to load vessels. There are also the remains of beach hardening mats, which were laid to enable tanks to be taken onto the landing craft. It was from here that the 4th/7th Royal Dragoon Guards departed on 3 June 1944, to land on Gold Beach five minutes before the main assault in Sherman amphibious Duplex Drive tanks.

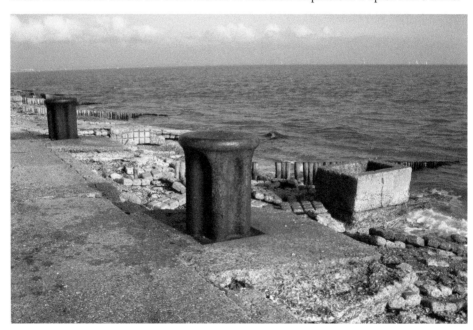

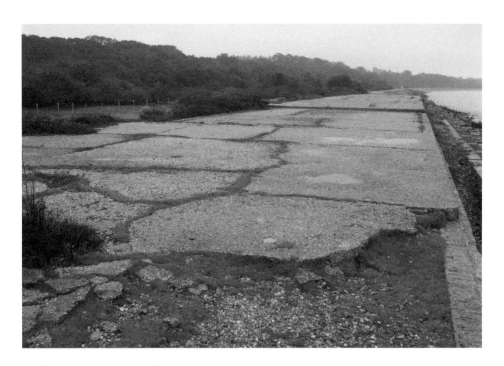

Mulberry Construction Site

Before the invasion, the concrete platform, seen above at Lepe, was used as a manufacturing site for six massive caissons, which were later towed across the English Channel to form part of the Mulberry Harbours. Again much evidence remains of this activity, such as the slipways that were used to launch the caissons at high tide (*below*). Also the housings that contained winches and trigger release gears, which held the concrete giants in position until they were ready for launching. It was also from here that the PLUTO pipeline left the mainland bound for the Isle of Wight, to carry fuel under the English Channel.

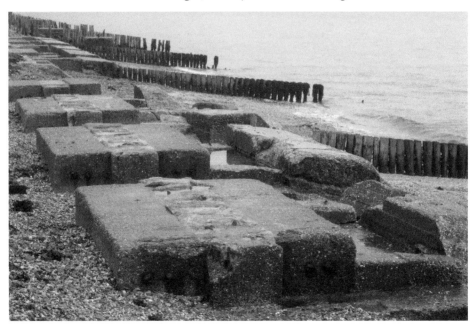

Grand Slam

Ashley Walk bombing range was another major use of New Forest land. Some of the development work for Barnes Wallis's bouncing bomb was carried out here. A replica of a German submarine pen was built at the site to allow scientists to develop a bomb capable of penetrating the thick concrete of these bunkers. The solution was Grand Slam, a 10,000-kg device that would cut deep into the ground before exploding. This would be the biggest bomb ever dropped on UK soil. The photograph above shows the replica pen, now covered in earth and foliage, while below we see the last remaining observation shelter on the range.

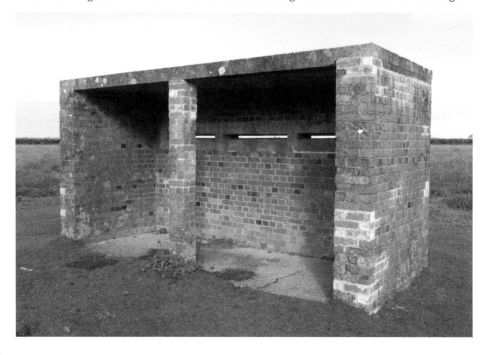

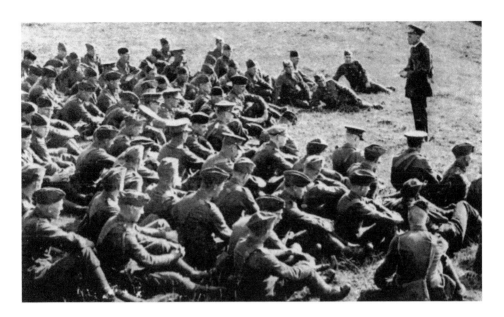

A Cross of Oak

Wartime activity within the New Forest affected the whole area and its busiest period was in the build-up to D-Day when camps sprung up everywhere to accommodate troops from all the Allied nations. The cross at Mogshade Hill, pictured below, is made from New Forest oak and is a memorial to the Canadian forces that camped here. An original cross made from pine was erected on this site in April 1944 by the padre of the 3rd Canadian Division, who held daily services here as the troops waited to embark from Portsmouth. The picture above shows a padre delivering a service to troops under similar circumstances.

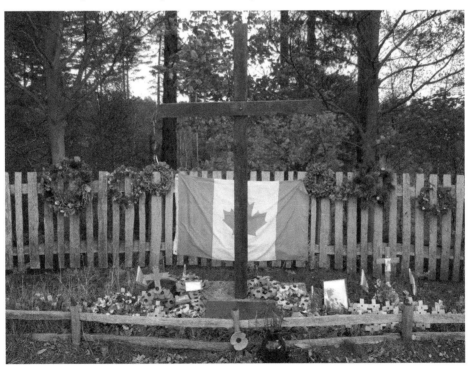

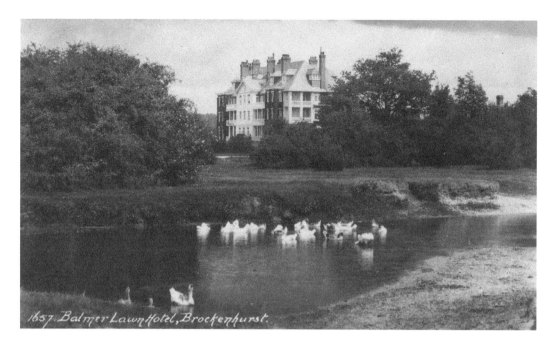

1657. Balmer Lawn Hotel, Brockenhurst.

An Alternative Venue

The Balmer Lawn hotel in Brockenhurst (*above*) was among many buildings in the area to be pressed into service. Here Eisenhower, Montgomery, and other members of the invasion staff would meet to discuss their plans, as an alternative venue to Southwick House. Breamore House (*below*) near Fordingbridge had various roles. Among them it was the HQ of the New Forest Home Guard, who patrolled the area on horseback. Later, it was used by the American general George S. Patton as his pre-invasion base. The great hall was used as a map room, where plans of Utah and Omaha beaches were displayed.

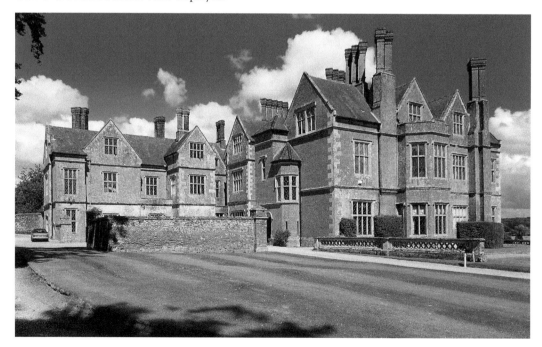

1051 PONIES IN NEW FOREST.

Tragedy at Woodgreen

Tragically, the publican's daughter at the Horse and Groom Inn in nearby Woodgreen, seen below today, was killed by a speeding American vehicle. Even the forest itself played its part, as swathes of trees were felled and burnt to make charcoal, which was then used to provide, among other things, absorbers for around 40 million gas masks. So just as the cityscapes of Portsmouth and Southampton were irreversibly changed by the war, so was the rural landscape of the New Forest, which in places today looks very different from how it might have appeared in the 1940s. Above is a typical postcard from the time.

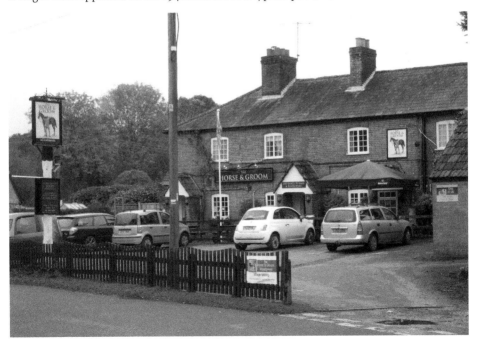

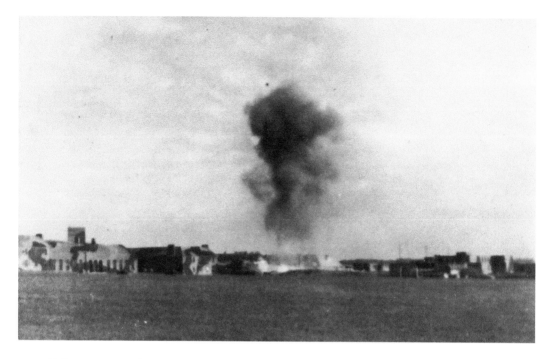

Fighter Command

Arguably Hampshire's most important wartime airfield, RAF Middle Wallop opened in 1940 as a training school for new pilots. But with the advent of the Battle of Britain, it became a sector operations HQ within No. 10 Group Fighter Command. A number of fighter squadrons would operate from here, including 609 Spitfire Squadron, which was the first to shoot down 100 enemy aircraft. On 14 August 1940 a single German aircraft dropped five bombs on the airfield, damaging hangars and killing three airmen. The photograph above was taken during the raid. Below we see the control tower today.

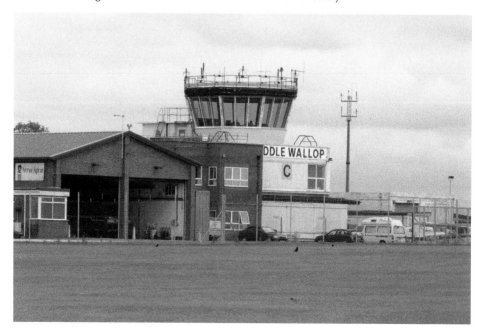

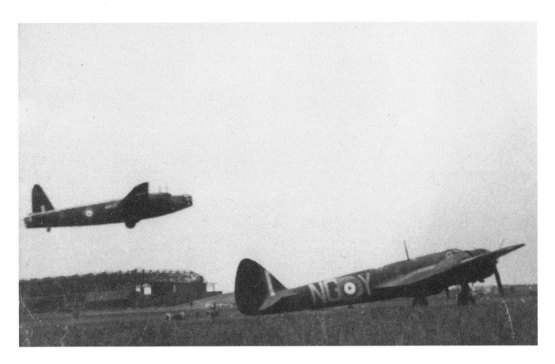

Night Fighters

Another unit to enjoy success from Middle Wallop was 604 Squadron, who specialised in night fighting. On arrival they were flying Bristol Blenheims, but later re-equipped with Bristol Beaufighters, which had four 20 mm cannons and Mark IV AI radio-location, or radar as it was later known. The squadron provided night-time defences during the Blitz from late 1940 until mid-May 1941. During this time they claimed fifty air victories, fourteen by Flight Lieutenant John Cunningham. The photograph above shows a 604 Squadron Blenheim on the ground at Middle Wallop, while below are the same hangars today.

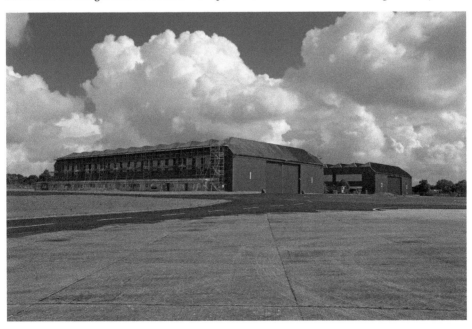

American Fighter Command

The photograph above shows radar operators of 604 Squadron, who also played a crucial role, as well as the pilots. Middle Wallop was later used as a Fighter Command HQ by the American Ninth Air Force. In December 1943 it jointly accommodated the 67th Reconnaissance Group, which flew Lockheed P-38 Lightnings and North American P-51 Mustangs (*below right*) on missions over the Continent to take photographs that would ultimately aid the invasion. In January 1945, the airfield was transferred to the Royal Naval Air Service and became HMS *Flycatcher*, which it remained until the end of the war.

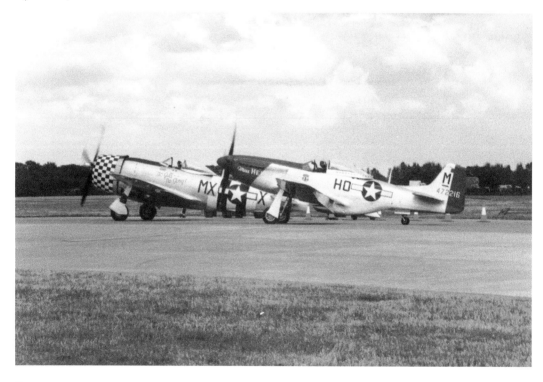

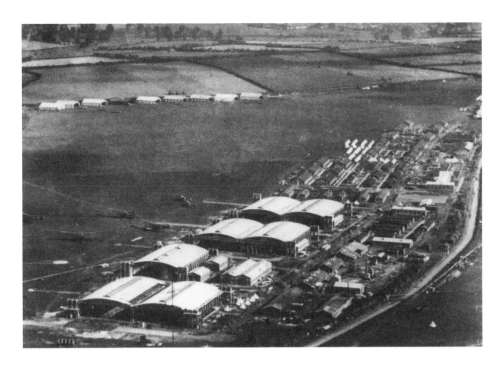

RAF Andover

At the start of the war RAF Andover (*above*) was the headquarters of Maintenance Command. It was attacked several times and during the Battle of Britain, Corporal Josephine Robins, a telephone operator in the Women's Auxiliary Air Force, was awarded the Military Medal after the air-raid shelter she was in took a direct hit, killing two people and injuring many more. Calmly she administered first aid to the survivors and superintended their evacuation. She was one of only six WAAFs to be honoured with this decoration during the war. The building below was the station guardroom and its strange tower once had a clock.

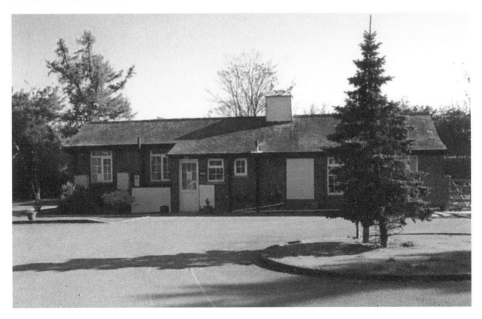

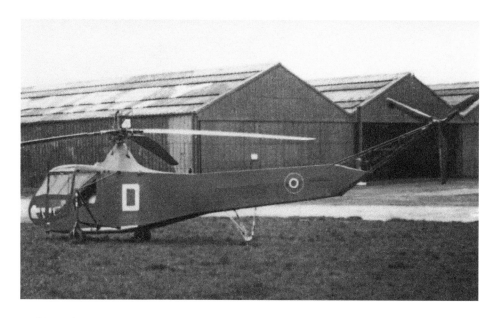

Making History

Andover was also the setting for the Air Observation Post, or AOP, School. Here pilots and observers recruited from the Royal Artillery learned how to direct the fire of ground guns onto enemy positions, by observing them from the air. But Andover would cement its place in history in January 1945 with the formation of the Helicopter Training School, where pilots trained to fly the Sikorsky Hoverfly I (*above*). Some of these men would go on to man 529 Squadron, the very first helicopter unit within the British Armed Forces. A massive distribution centre is now slowly devouring the runways (*below*).

American Red Cross

Another airfield, which was again used by both the RAF and the American Ninth Air Force, was opened in 1940 at Chilbolton. It was originally intended as a satellite of RAF Middle Wallop but during the Battle of Britain was upgraded to a fighter station in its own right. In November 1942 it became American Air Force Station 404 and was used as an aircraft maintenance depot where P-47 Thunderbolts, newly arrived from the USA, were prepared for battle. Mary Croft, who ran the American Red Cross Club at the station, is seen on the right with two of the airmen in front of a Nissen hut. Below, a Nissen hut at the site today.

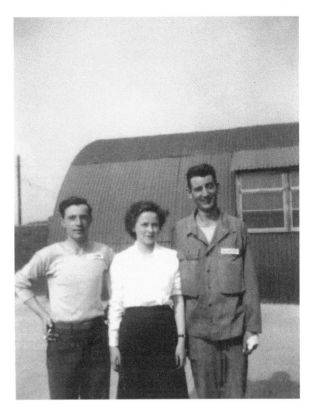

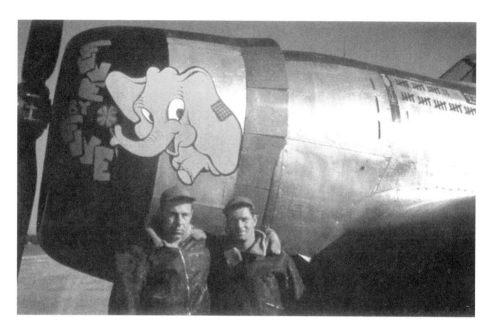

Post-Invasion Ace

In early 1944, with three squadrons of the 368th Fighter Group in residence, operational sorties were mounted over the Continent from Chilbolton. On 12 June Major Randall Hendricks became the first post-invasion Allied ace when he shot down four Focke-Wulf 190s in quick succession, with a fifth ten days later. The photograph above shows an example of Thunderbolt cowling art, while the building below is a survivor from the period. After the invasion, Chilbolton was selected as one of several airfields in England to participate in the airborne landings in Holland, known as Operation *Market Garden*.

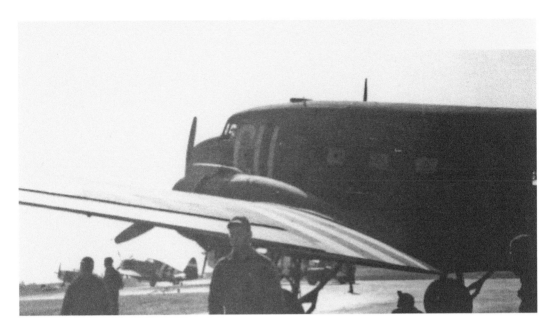

Operation *Market Garden*

On 17 September 1944, men of the 101st Airborne Division would be carried into battle from Chilbolton by the C-47 aircraft of the 442nd Troop Carrier Group, parachuting out near Veghel and Son. Above, a C-47 can be seen at the airfield. During the operation four aircraft were shot down. Over the next few days follow-up operations were also staged from the airfield with C-47s and Waco gliders. Of the fourteen carrier groups that took part in Operation *Market Garden*, the 442nd sustained one of the highest aircraft losses. Today a memorial can be found at the site dedicated to those who didn't return (*below*).

Other Hampshire Airfields

There were many other wartime airfields in Hampshire of varying size and importance, among them Hythe, which was used by BOAC as a maintenance base for their flying boat service; Lasham, operated by both Army Co-operation Command and Fighter Command; Odiham, again largely dedicated to Army Co-operation; Thruxton, mainly a storage facility for Horsa gliders; and Worthy Down, used by both the Fleet Air Arm as HMS *Kestrel* and Supermarine for Spitfire development flying. On the left, RAF flags hanging in Odiham's All Saints church. Below, the air traffic control tower at Thruxton today.

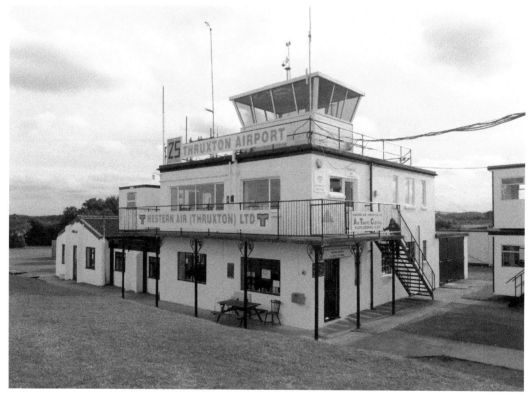

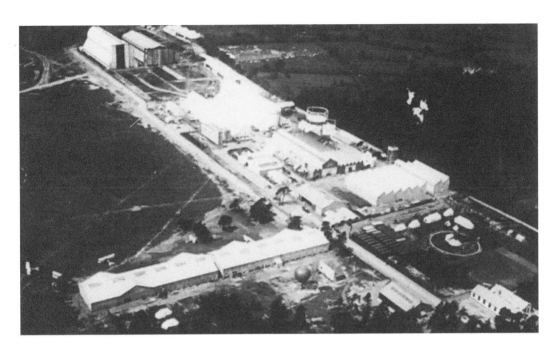

Royal Aircraft Establishment

Throughout the war a lot of the technical developments affecting British military aviation were carried out at the Royal Aircraft Establishment at Farnborough (*above*). The establishment encompassed a number of locations around the country, and at Farnborough scientists and engineers worked mainly on engine problems (*below*). One of its many innovations was known as the Miss Shilling's Orifice. Beatrice Shilling was an aeronautical engineer who became a specialist in aircraft carburettors. She was tasked with working on a serious problem affecting the Rolls-Royce Merlin engines used in both Hurricanes and Spitfires.

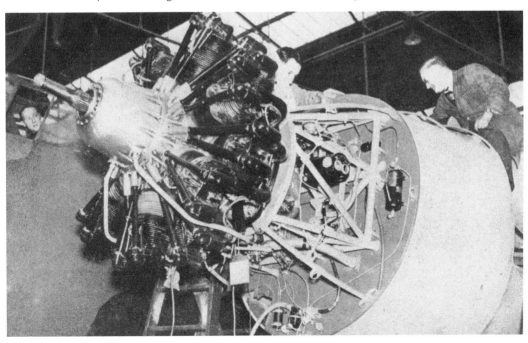

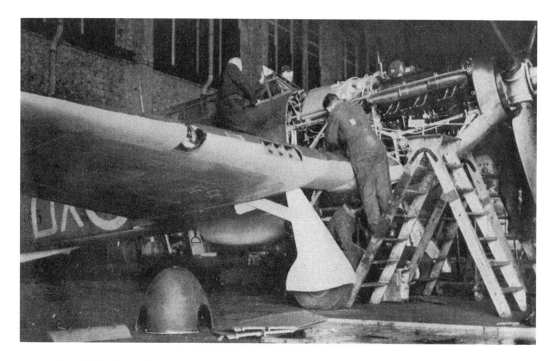

Miss Shilling's Orifice

Merlin engines had a tendency to misfire or cut out when a pilot was diving. This was costing Allied lives and Beatrice and her team tried to find a solution. She came up with an ingenious device, a small brass disc with a hole in the middle, which fixed into the engine's carburettor and was able to reduce fuel deprivation to the engine. It became known as 'Miss Shilling's Orifice' and, after testing demonstrated its effectiveness, it was used in all future Allied aircraft. But this was just one example of the important work carried out at Farnborough. Above, technicians work on a Hurricane and below, the airfield today.

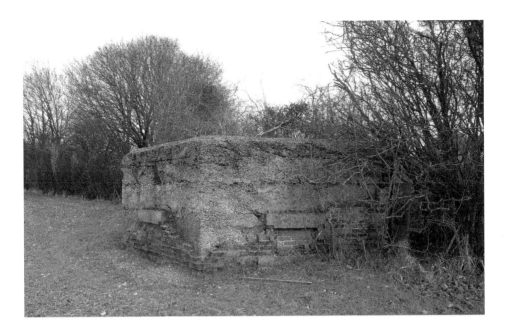

Preparing for an Invasion

Similar to all counties in southern England, some of the most visible reminders of the war in Hampshire are the pillboxes and other defences that were hurriedly built in the summer of 1940 when it was believed that the Germans were about to invade the country. Some of these protected the coast or crucial sites, such as the example above, which was part of the airfield defences at RAF Middle Wallop. Others were part of formal stop lines that would hold the invaders back. The example below can be seen on the Ringwood Stop Line at Breamore, disguised as part of an old mill complex.

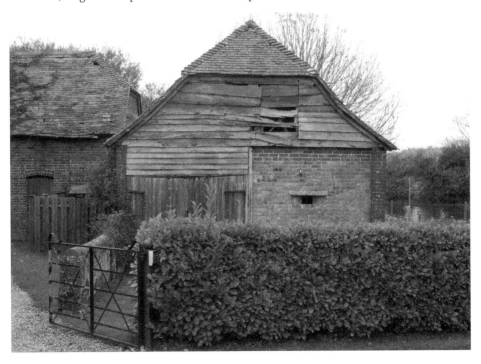

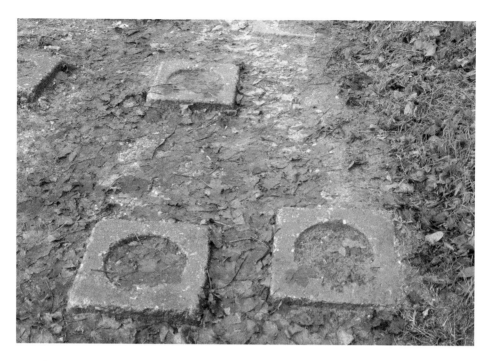

A Defended Bridge

The indentations seen above were sockets for spider mines, and can be found on Blacksmith's Bridge near Dogmersfield on the Basingstoke Canal section of the GHQ Stop Line. There were nine in total and these would have been sufficient to disable a tank or vehicle attempting to cross here. This would effectively block the passage and make it easier to keep the enemy at bay. If the Germans then decided to try and go around the bridge and cross the canal itself they would have encountered a series of anti-tank obstacles, including the formidable blocks of concrete seen below that were known as pipe cylinders.

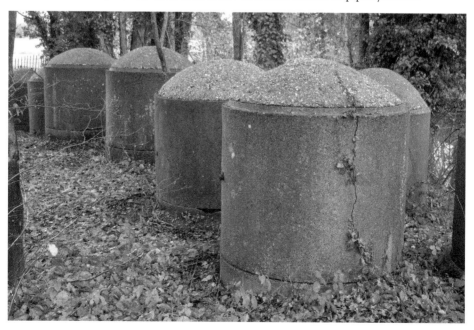

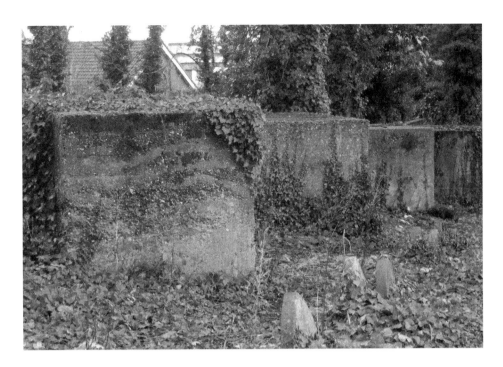

Anti-Tank Islands

A number of towns in the area, including Basingstoke, became what were designated as 'anti-tank islands' surrounded by defences. Each island had a 'keep' as a last stronghold; in the case of Basingstoke this was in the vicinity of the railway station, where you can still see some of the evidence nearby, such as the line of tank traps seen above in an adjacent cemetery, or the holes in the railway bridge pictured below, which were apparently cut out so that the defenders could fire their weapons through them. These defences were initially manned by regular troops and later the Home Guard after the invasion threat had receded.

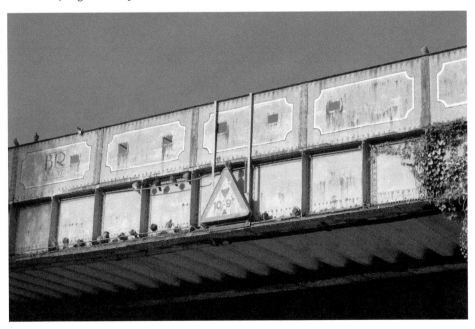

Home Guard

The 3rd Basingstoke Battalion Home Guard stood ready to defend their locality against invaders. They were largely tasked with guarding vital points, such as the area around the railway station, or the Thornycroft vehicle factory, now the site of a well-known supermarket. How successful all these defences would have been in preventing German troops from reaching London and the Midlands we will never know, but they would undoubtedly have met with stiff opposition. Below, we see Basingstoke railway station today and above, Don Smith pictured in the uniform of a Southampton Home Guard battalion.

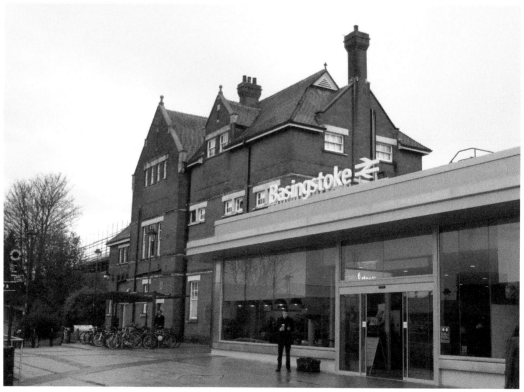

The Hampshire Regiment

The City of Winchester is an ideal place to end our tour of wartime Hampshire, as for hundreds of years it was a focal point for men wishing to join their county regiment, the Hampshire Regiment, battalions of which served in many campaigns during the Second World War, from North Africa to Normandy. The postcard on the right illustrates some of the regiment's badges. In 1946 it was awarded the 'Royal' prefix in recognition of its wartime service. Serle's House in Southgate Street, pictured below, today houses the regimental museum and archives. It is also the offices of the Lord Lieutenant of Hampshire.

THE HAMPSHIRE REGIMENT

Breast Plate, 1792 On Regtl. Colour, 1844

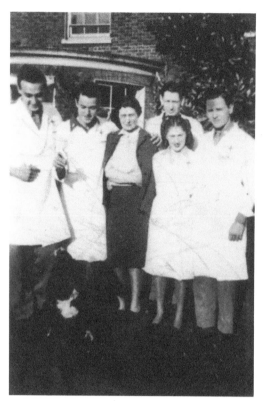

A Farewell to Hampshire

From 1858, the elegant Peninsula Barracks (*below*, today) were the home base and training depot for both the Rifle Brigade and the King's Royal Rifle Corps, and remained so until 1944 when they were temporarily occupied by the 9th US Infantry Division as they prepared for D-Day. It was here that American troops were reviewed by both Winston Churchill and General Eisenhower, while in town, Minster House was used as the American Red Cross officer's club. In the photograph above, female staff and American officers are dressed in Red Cross coats at a party shortly before leaving for Normandy.